MW00561648

**Around The World, Inc.**
28 West 40th Street • NYC, NY 10018
Tel: 212.575.8543  Fax: 212.575.8552
Domestic & International
Fashion Publications
*Subscriptions Available*
www.amijayinc.com

# The T-Shirt:

a collection of designs

ROCKPORT

First published in the United States of America by
Rockport Publishers, Inc, a member of
Quayside Publishing Group
33 Commercial Street
Gloucester, Massachusetts 01930-5089
Telephone: (978) 282-9590
Fax: (978) 283-2742
www.rockpub.com

First published in Singapore in 2006 by:
Page One Publishing Private Limited
20 Kaki Bukit View
Kaki Bukit Techpark II
Singapore 415956
Telephone: (65) 6742-2088
Fax: (65) 6744-2088
enquires@pageonebookshop.com

Library of Congress Cataloging-in-Publication data available.

ISBN-10: 1-59253-306-X
ISBN-13: 978-1-59253-306-0

Author: Luo Lv, Zhang Huiguang
Editor: Chen Ciliang
English text: Rochelle Bourgault

Printed and bound in China

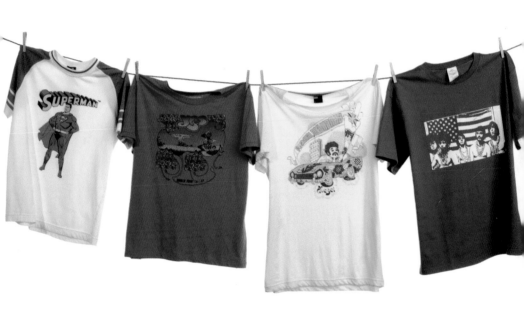

CONTENTS

# The Legend of the T-Shirt

1

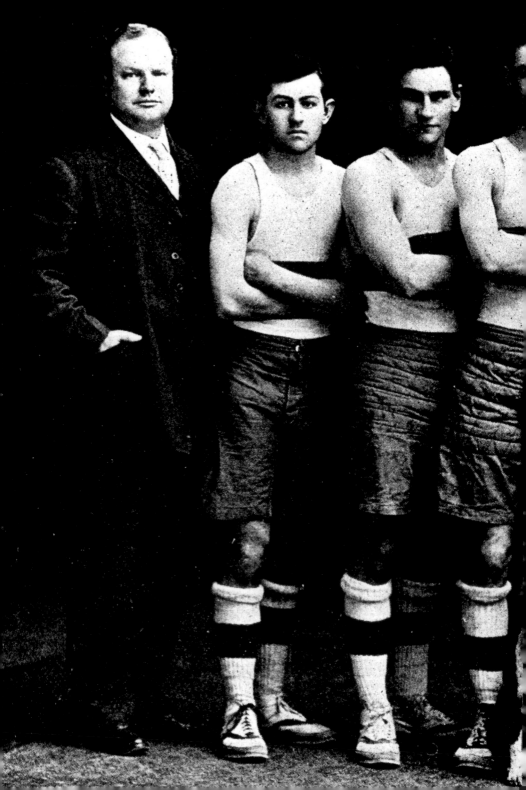

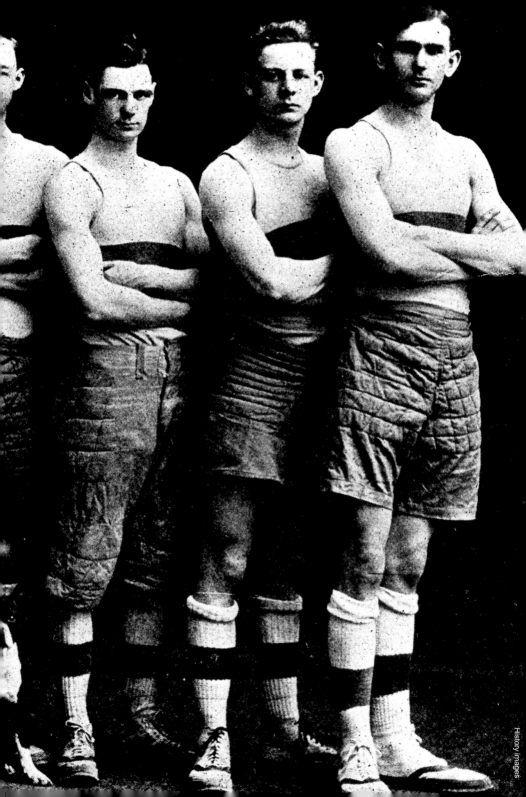

The word T-shirt originated from the letter "T" and the word "shirt." In the seventeenth century, workers unloading tea boxes from boats in the harbor of Annapolis, Maryland, used to wear a short-sleeved shirt whose shape evoked the letter T. In the 1880s, U.S. Navy soldiers used to wear lightweight cotton shirts that dried easily. These shirts could also be worn as underwear to shield their clothing from sweat. In 1913, the U.S. Navy approved the T-shirt as part of its uniform. The Industrial Revolution paved the way for the technology that allowed the mass production of T-shirts, and soon, T-shirts became part of the uniforms of soldiers, workers, and sailors. By 1920, the word T-shirt appeared in official U.S. dictionaries.

The widespread T-shirt trend was born in the 1950s, thanks to the movies. Marlon Brando, James Dean, and Art Carney, all dressed in T-shirts, created the *tough guy* image that launched the T-shirt into mainstream popularity. In 1951, a chiseled Marlon Brando starred in the film *A Streetcar Named Desire*. His tough, coarse, working-class Stanley Kowalski, dressed in a white T-shirt, became an iconic image. The film earned Brando his first ever Oscar nomination. In 1953's *The Wild One*, Brando played Johnny Strabler, a rebel on a Harley-Davidson; a white T-shirt under a black leather jacket became the standard look for young men during this era.

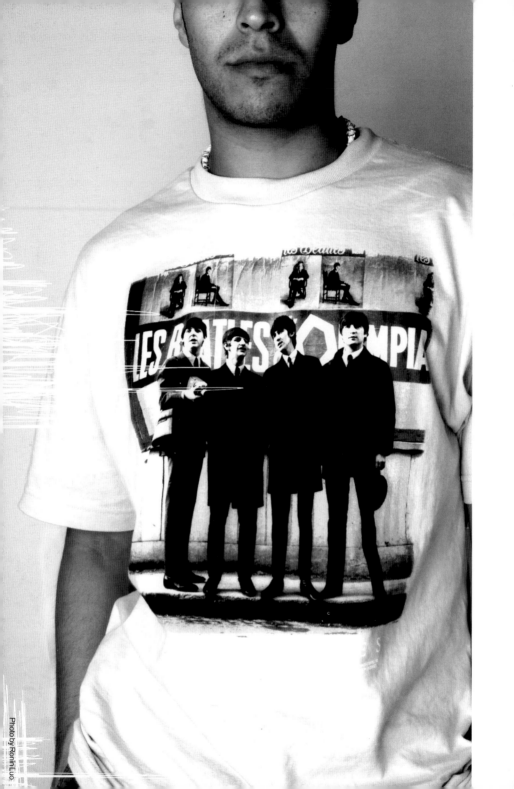

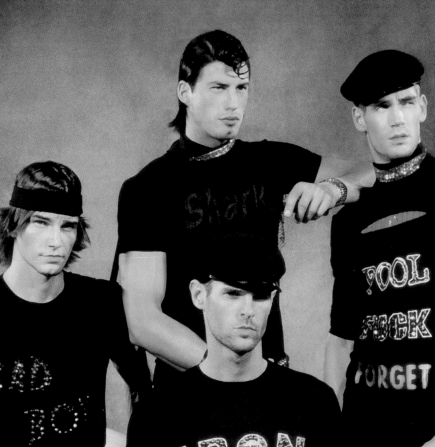

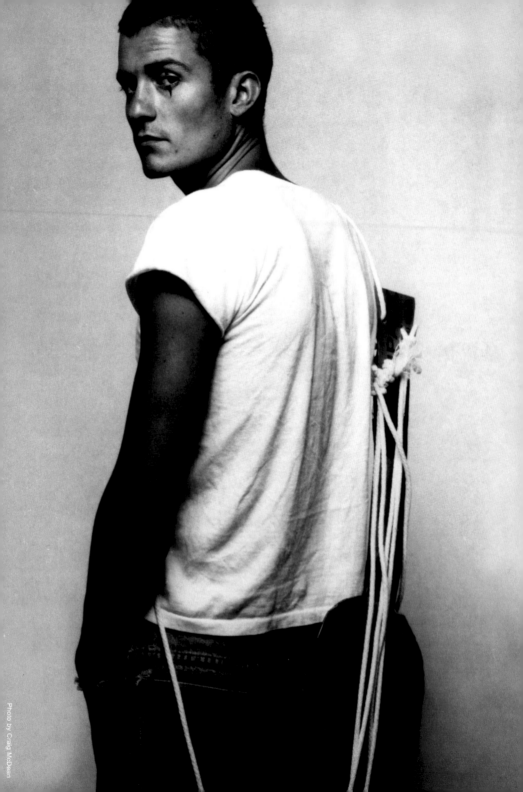

**019**
T-SHIRT

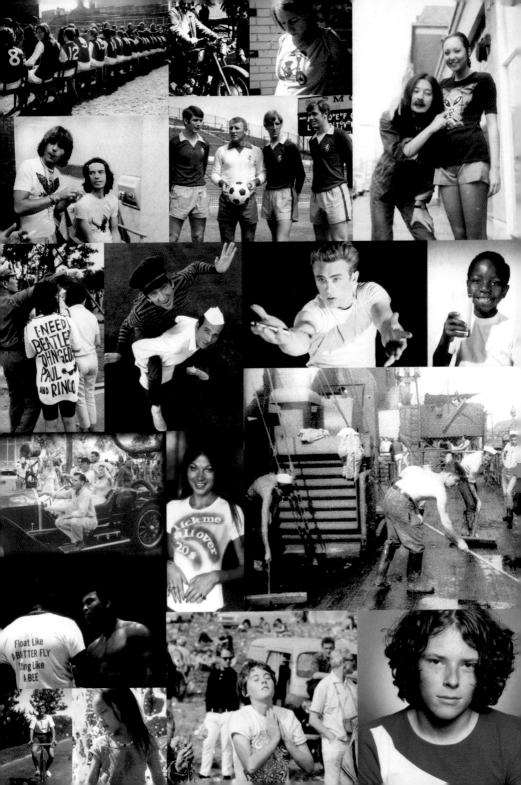

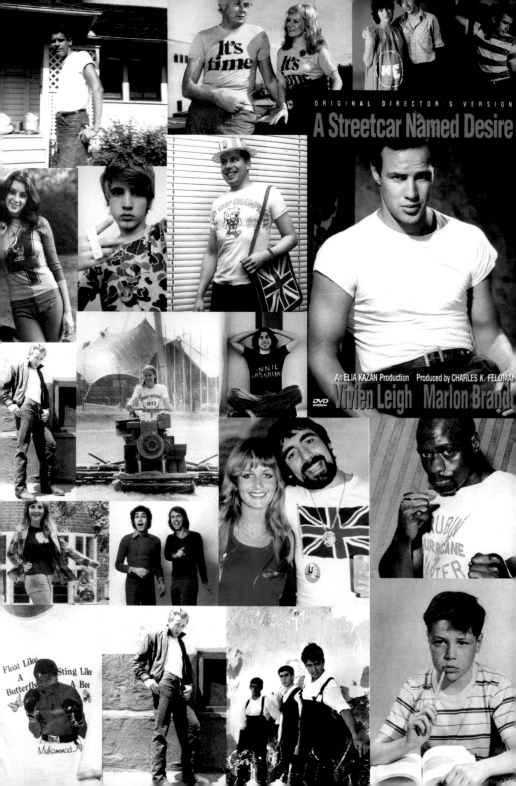

ORIGINAL DIRECTOR'S VERSION

A Streetcar Named Desire

An ELIA KAZAN Production    Produced by CHARLES K. FELDMAN

Vivien Leigh    Marlon Brando

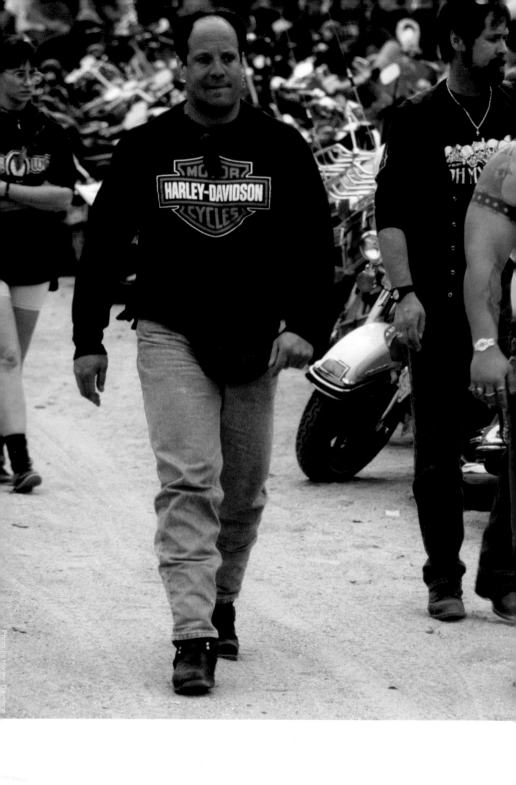

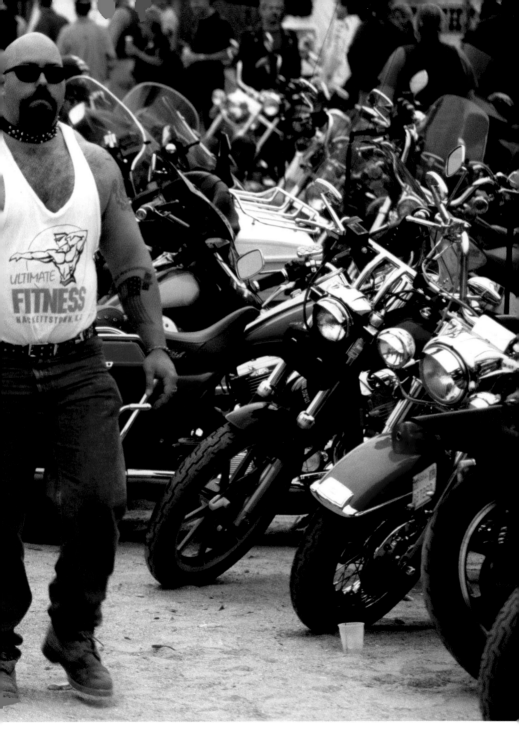

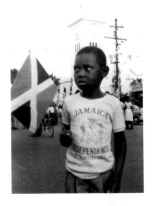

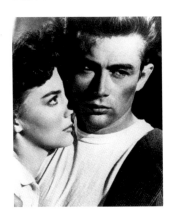

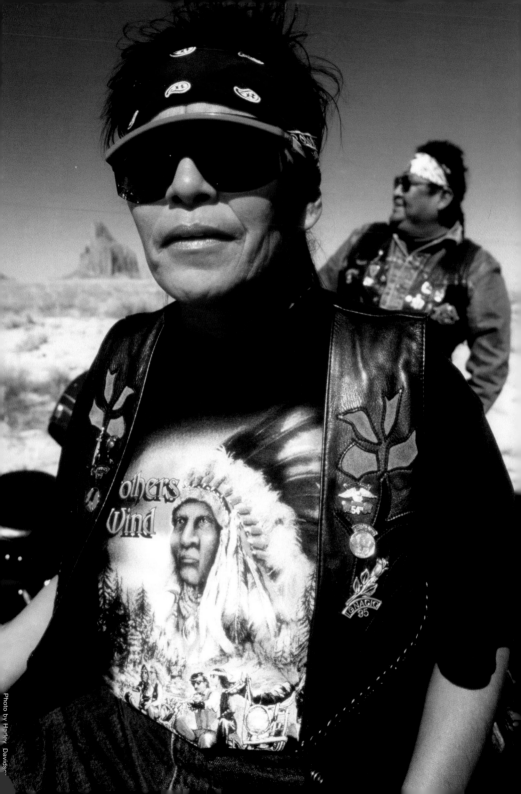

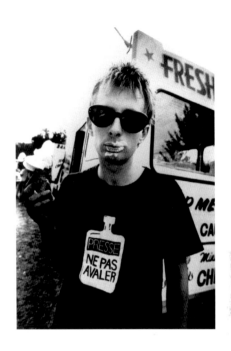

In the 1955 film *Rebel Without a Cause*, James Dean turned the image of a white T-shirt under a red jacket into a symbol of rebellion, turning the T-shirt into a historical icon. When the Baby Boomers came into adolescence after the war, feelings of a lack of national security appeared. This generation of "hippies" participated in anti-war movements as well as a sexual revolution. With widespread rebellion challenging social norms, T-shirts became a forum for a rebellious attitude. From standard uniform to means of expression, T-shirts upended tradition within one generation. Young people dressed in T-shirts with in-your-face, lewd messages printed on them and wore torn jeans to criticize the U.S. government.

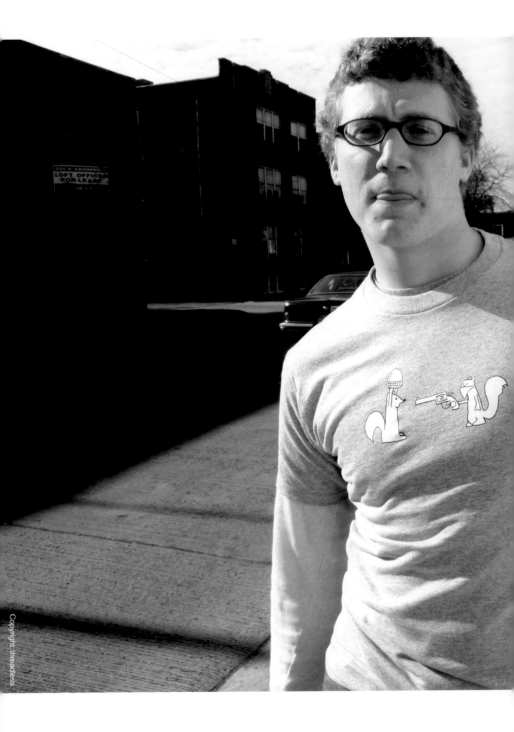

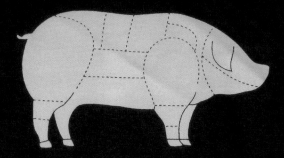

Tout est bon dans le cochon!

**032**
T-SHIRT

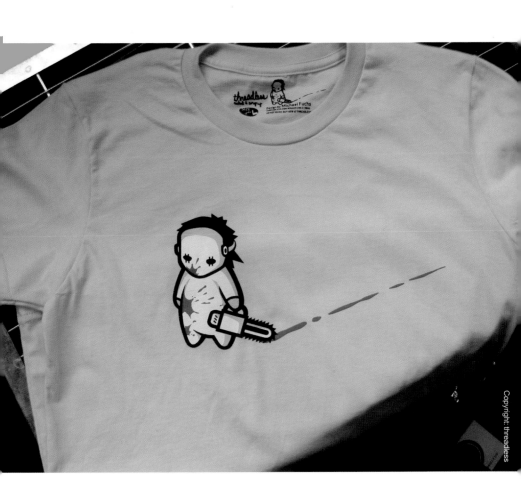

**033**
T-SHIRT

**034**
T-SHIRT

035
T-SHIRT

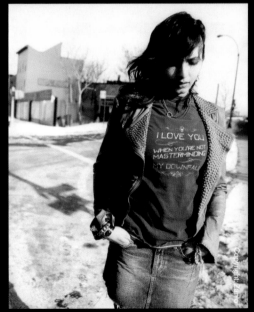

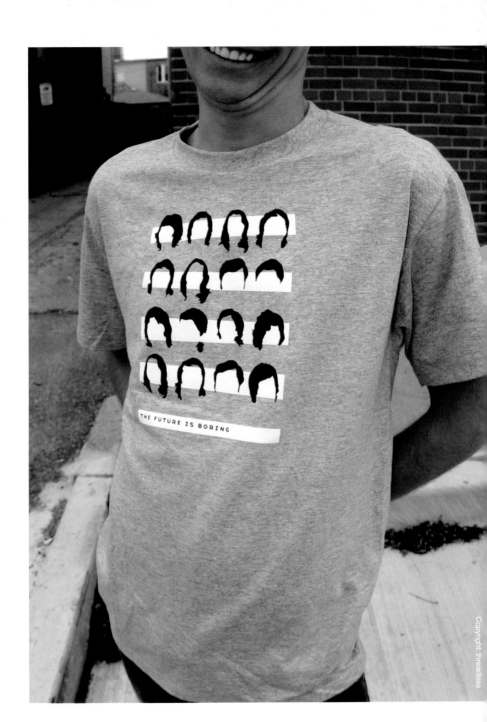

THE FUTURE IS BORING

**037**
T-SHIRT

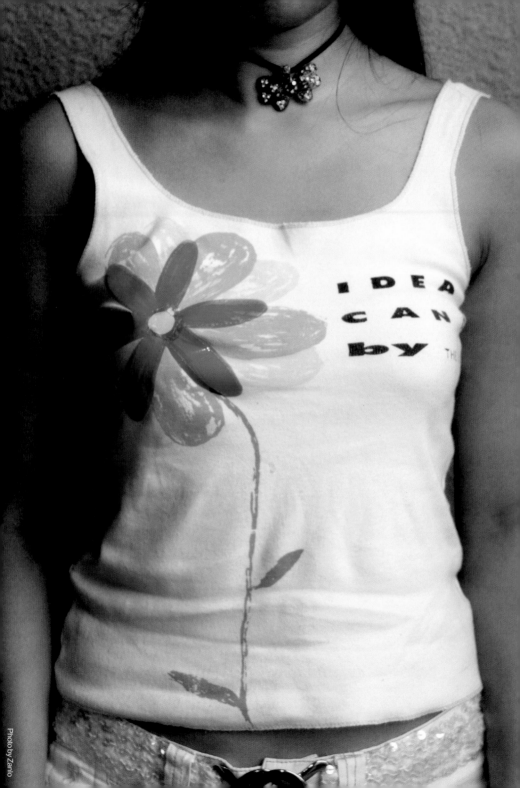

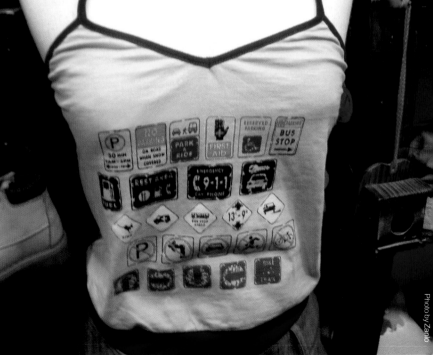

With the technical advancement of dyeing and printing techniques in the 1960s, T-shirts took on greater commercial value. Rock-n-roll bands capitalized on this, and created fan memorabilia. Film studios printed posters and publicity stills on T-shirts. T-shirts with logos were given away as promotional items by innumerable companies. Even during presidential elections, supporters wore T-shirts with the candidates' slogans. The anti-war sentiments brought on by the Vietnam War were printed, and the shirts became the uniform of the protest march. Also starting from that time, T-shirts became a medium for commercial promotions. This once humble garment became more vivid and mainstream.

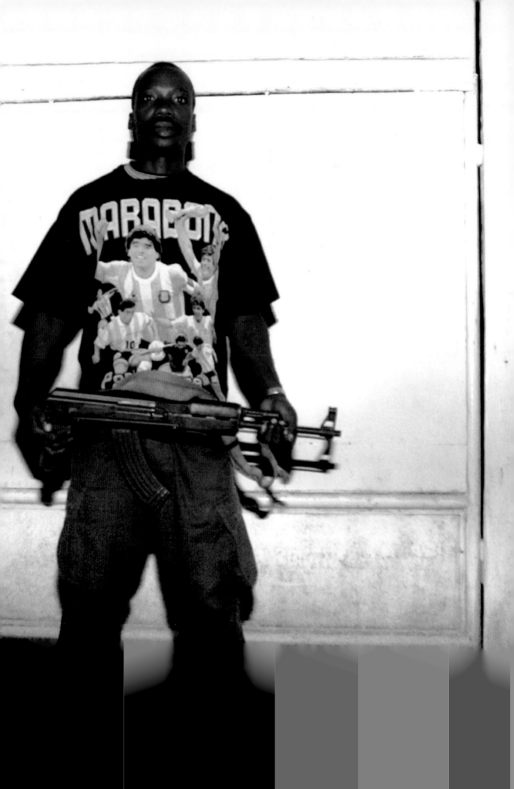

**042**
T-SHIRT

**043**
T-SHIRT

Idol Power

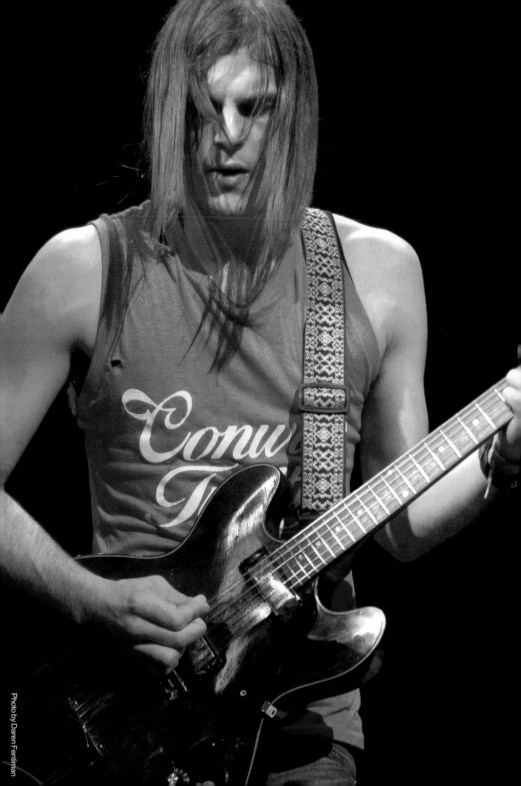

Photo by Daren Fentiman

T-shirts became an instrument of worship towards pop-culture idols. A mirror of cultural development, T-shirts became synonymous with the music industry. T-shirts with portraits of pop singers gained popularity in the early 1970s. Live performances and album covers were regular design themes. T-shirts quickly became emblems of all areas of pop culture; music and movie stars and professional athletes autographed the T-shirts, increasing their value as collectibles.

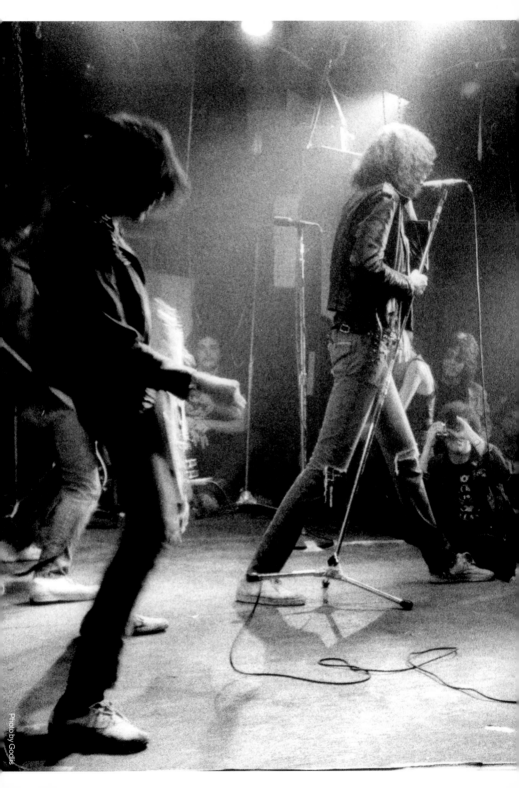

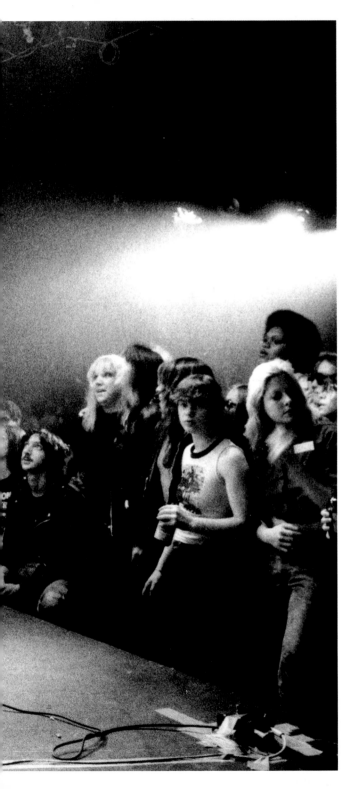

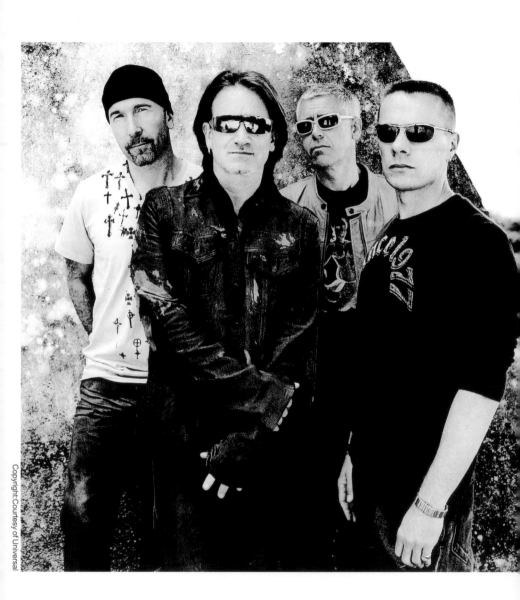

**050**
T-SHIRT

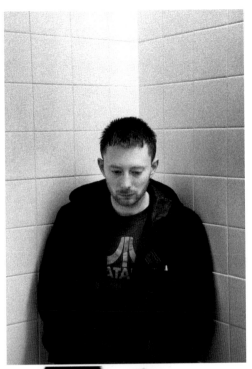

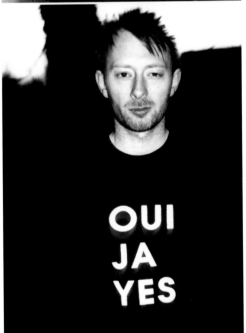

**053**
T-SHIRT

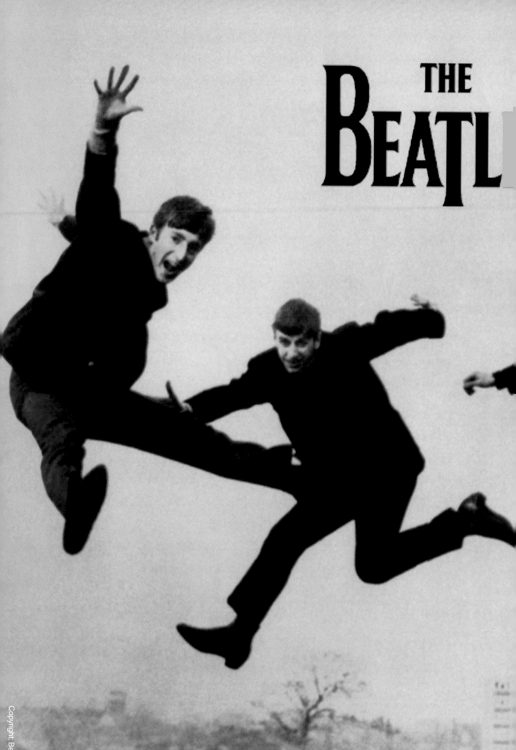

THE
BEATL

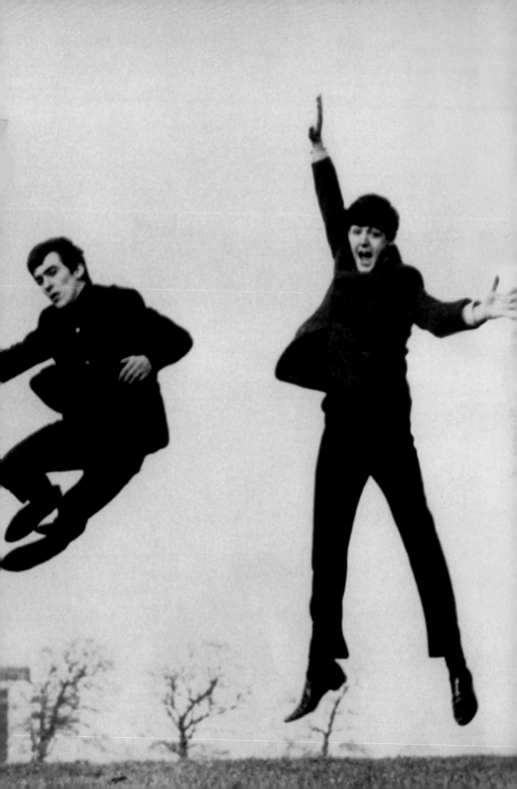

Like rock-n-roll, Coca-Cola, blue jeans, and hamburgers, the T-shirt is a symbol of American culture. For decades, rock-n-roll bands have been the central element in T-shirt design. Whether you favor Linkin Park or Kurt Cobain, rock-n-roll T-shirts are venerable collectibles, in addition to CDs, bootleg recordings, and posters. T-shirts with images of singers have been popular since the 1970s, and are an ideal fashion choice for music fans, not to mention key moneymakers for the musicians and promoters.

In the mid-1950s, the legend of Elvis Presley was born. Combining country music with R&B and blues, Elvis presented a unique singing style with a wild dance moves and started a rock-n-roll storm. At that time T-shirts were mostly considered to be underwear and to wear it out was seen as rebellious. Students were not allowed to wear T-shirts on campuses in the U.S. until the 1970s.

On August 15, 1969, when most people were talking about the moon landing and the Vietnam War, 450,000 people gathered in the Max Yasgur farmland in Sullivan County, New York, for the famous Woodstock music festival. Dressed in T-shirts and bell-bottom pants, participants shouted slogans of peace, anti-war, humanity, and equality. For three days in the rain, hippies dressed in T-shirts featuring slogans such as "Make love, not war," sang, laughed, and protested.

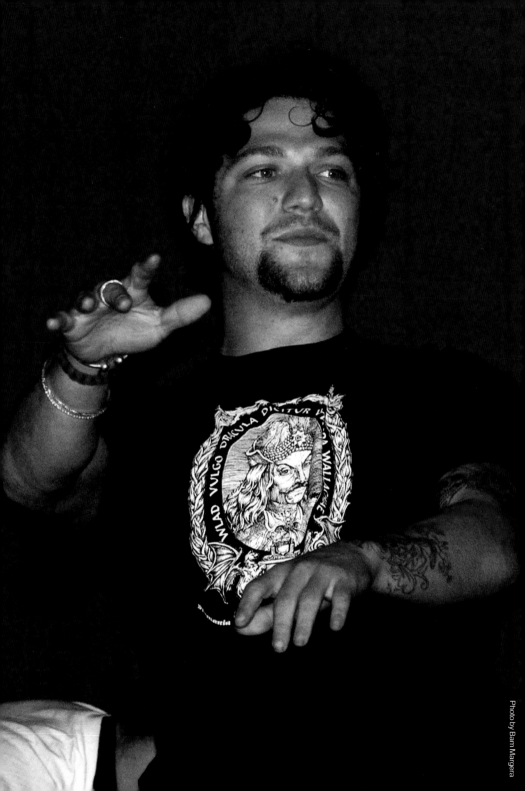

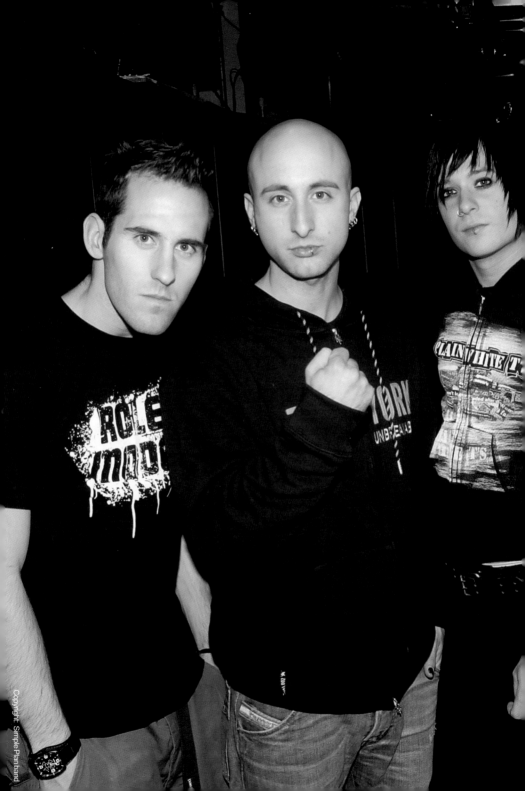

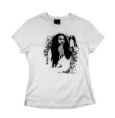
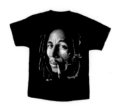

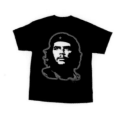

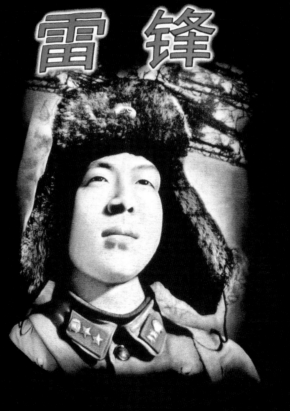

In My
Fathe
Den

Miranda Otto        Colin Moy

excellent atmospheric thriller"

A film by Brad McGann

WINNER  WINNER

雷锋

T-shirts became a sign of rebellion and punk when rock-n-roll became mainstream. Stirred up by the Velvet Underground, the New York punk scene seemed to deliberately resist pop and the visionary rock-n-roll. With no less melody, but denser and more aggressive guitars, punk music became a social revolt. Lyrics featured themes of drug abuse, sexual promiscuity, sadism, and society's underbelly. T-shirts had become the mirror to reflect cultural development, in this sense it was in line with the music.

Formed in the 1970s, AC/DC was famous for their defiant and dissonant sound. The logo of this great heavy metal band was one of the most used design element on T-shirts.

Another wonder of musical history, the Beatles have created, and still maintain, a legacy unsurpassed by any other band. In 1964, their third album, *A Hard Day's Night*, began their legendary rise to fame. "Beatlemania" was the perfect word for the phenomenon they created. Portraits of John Lennon, Paul McCartney, George Harrison, and Ringo Starr were emblazoned across T-shirts. When John Lennon was shot and killed in 1980, a new wave of worship and nostalgia swelled, and incalculable numbers of new Beatles T-shirts were produced.

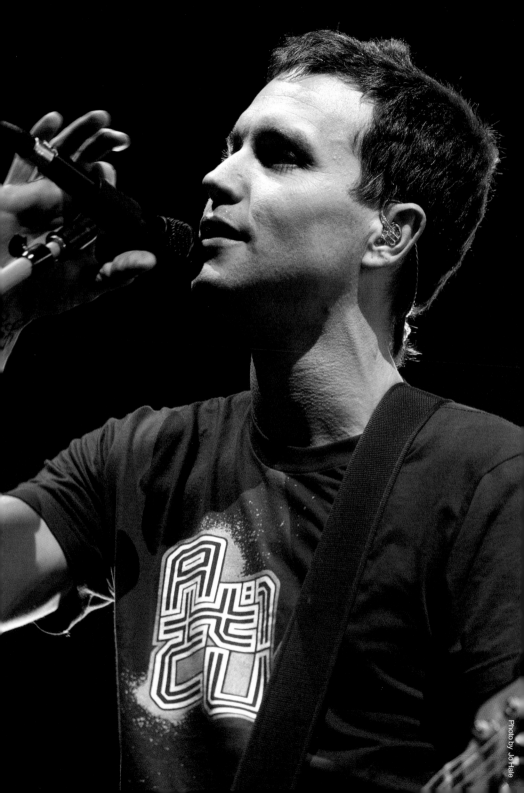

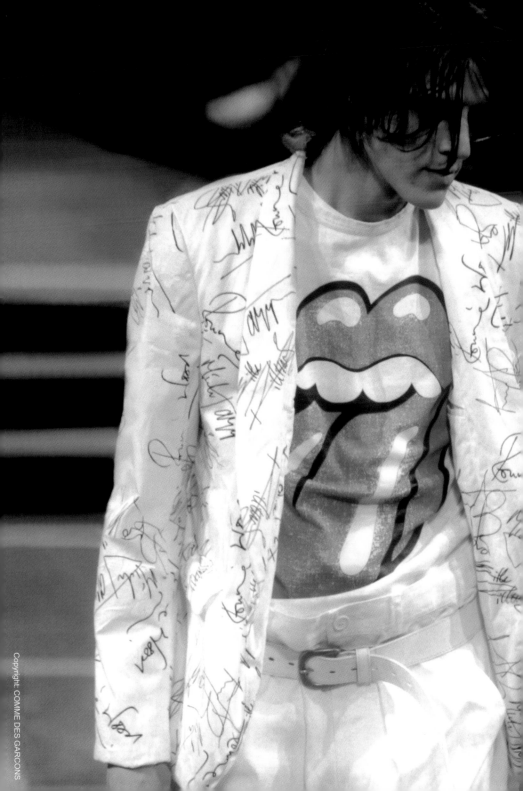

Bob Marley is internationally known as the Godfather of reggae. As reggae's seminal figure, he bridged cultural and racial divides through his music. No musician had ever won such unanimous adoration among the different races. When Marley died in 1980, he was regarded as a genius of his time. Now, T-shirts in memory of Marley use the Pan-African colors of red, gold, and green to remember him by.

With their aggressive persona and their rebellious attitude, the Rolling Stones were born bad boys. They were sharp, slick, and tricky—the symbols of the post-hippie movement. They were self-centered and heavy advocates of sex, love, drugs, and ultra pleasure. A pair of open lips with a long and lascivious tongue is the Stones' signature trademark, and it appears everywhere, including on T-shirts.

Before Nirvana rose to fame, grunge music was only a strange concept that was seen as anything but profitable. But record companies and music studios soon realized their mistake when *Nevermind* was released in 1991. A torrent of alternative music flooded the mainstream and Nirvana had become the poster children for the post punk period. It was the first time America, and beyond, accepted this style of music. The death of Kurt Cobain, in 1994, was not the ruin of rock-n-roll, nor was it the end of it. On the contrary, the record industry capitalized on its new martyr and Cobain's portrait became another T-shirt design element.

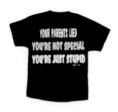
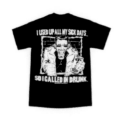

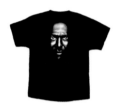
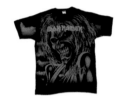

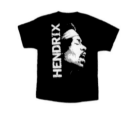

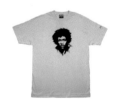
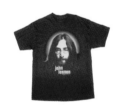

**067**
T-SHIRT

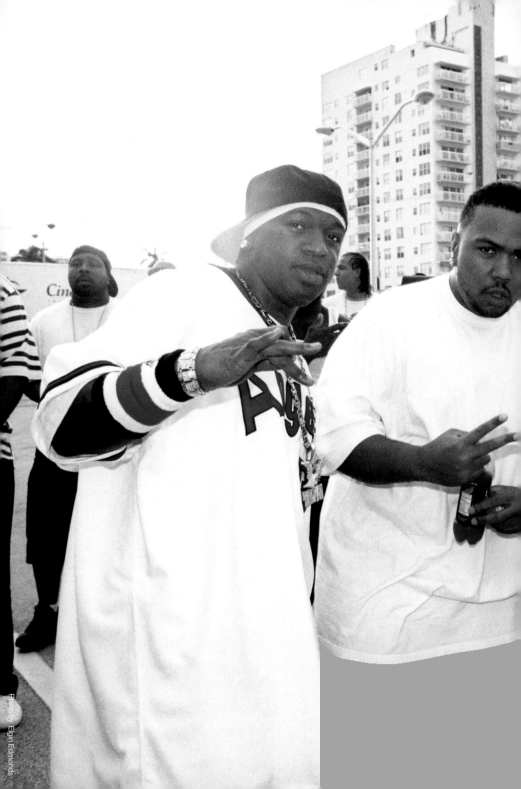

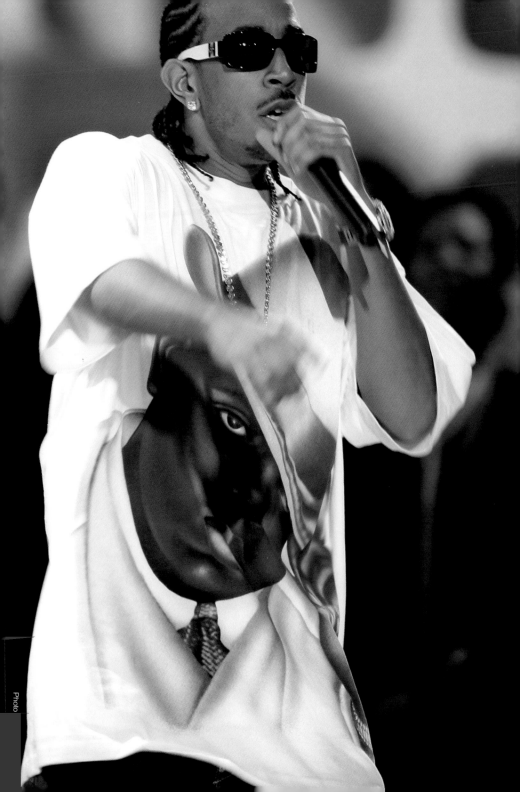

The oversized T-shirt is a hip-hop fashion staple. Long and loose T-shirts paired with oversized, low-slung jeans are classics of hip-hop style. This way of dressing is closely related to the hip-hop culture. In the late '70s, a new sound came from the streets of Brooklyn. A culture of music, dance, creativity, and artistry created an original avenue of self-expression, which included deejaying, emceeing, breakdancing, and graffiti art. Thirty years later, hip-hop music and style has moved from the streets of Brooklyn to the mainstream. Suburban teens, taking their fashion cues from their urban counterparts, have helped make the long, baggy T-shirt an American standard. Brands such as Tommy Hilfiger, Nike, Adidas, Puma, and Converse manufacture hiphop-style T-shirts, sportswear, shoes, and baseball caps. Hip-hop dressing has become a mainstream style.

The mainstays of long and loose T-shirts and baggy jeans are only a small part of hip-hop style. Hip-hop consists of old school and new school, representing the '80s and '90s, respectively, while also demonstrating the difference between East and West. Patches on clothes, torn jeans, wrist laces, and necklaces are characteristics of old school, while the T-shirt brands of DVS, PTS, Volcom, Expedition, DC, baggy pants, and skateboarding shoes are symbolic of new school.

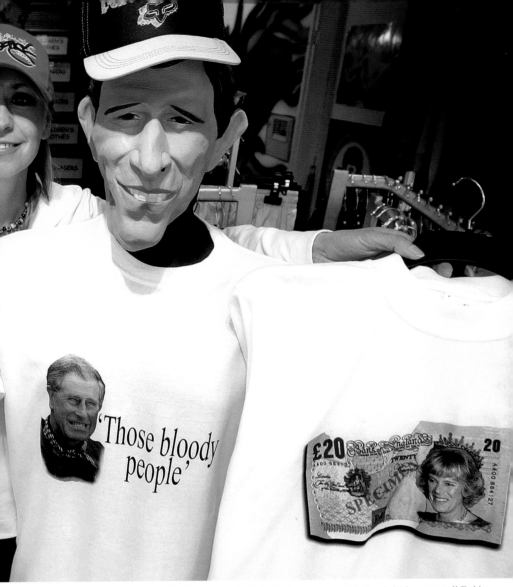

When Kobe Bryant was embroiled in a legal suit in 2003, a "Release Kobe" website began to sell T-shirts with the same slogan, selling 150 "collector's editions" that were handmade on the day of the court opening. Another entrepreneur created T-shirts with Kobe's name together with his team number and the logo of a Colorado jail. A large number of Kobe fans wore T-shirts saying "Kobe is innocent" and "Maybe it's not Kobe" during the basketball player's trial.

The infamous Michael Jackson trial of 2005 was held in a court at St. Maria, a town 164 miles north of Los Angeles. During the pop star's arraignment, a parking fee of $250 was charged per space each day. Peddlers, hoping to capitalize on the case, were everywhere around the courthouse selling T-shirts with Jackson's photos. The best sellers were T-shirts with slogans such as "Michael Jackson is innocent" and "Always support Michael Jackson."

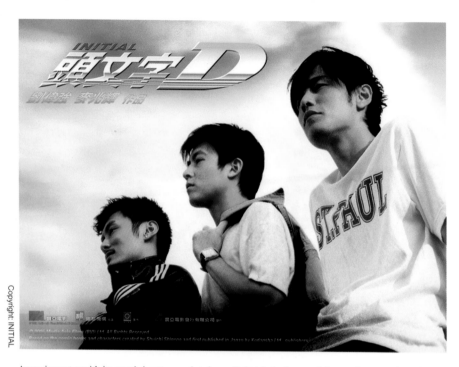

A movie poster with its stars' signatures printed on a T-shirt is the best tool for movie promotions. On June 19, 2005, "Initial D" was launched in Asia. In the movie, Jay was wearing a white St. Paul T-shirt. A few days later, dozens of the same T-shirt appeared on the streets in Japan and Hong Kong. One cinema even accepted the T-shirt as the ticket; only viewers wearing them were allowed in.

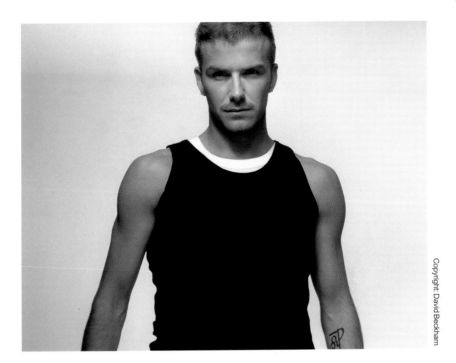

One of the most famous British soccer players of all time, David Beckham, was born to a poor family. Now, he has become a sports deity and is worshipped throughout the world. When Beckham was injured in a 2002 soccer game, the *Sun* ran a photo of Beckham's injured foot so that every reader could touch and heal it. Beckham wore the number 7 when he was in Manchester United, and "David 7" were the words most frequently donned by David's fans. Fashion designers used "David 7" in their products to meet the demands of feverish fans. Vintage recently launched a new series of T-shirts with the audacious slogan, "This is the perfect T-shirt used by Mr. & Mrs. Beckham in their leisure time." Once on a visit to Los Angeles, Beckham's wife, Victoria, brazenly wore an attention-grabbing "I am Mrs. Beckham" T-shirt.

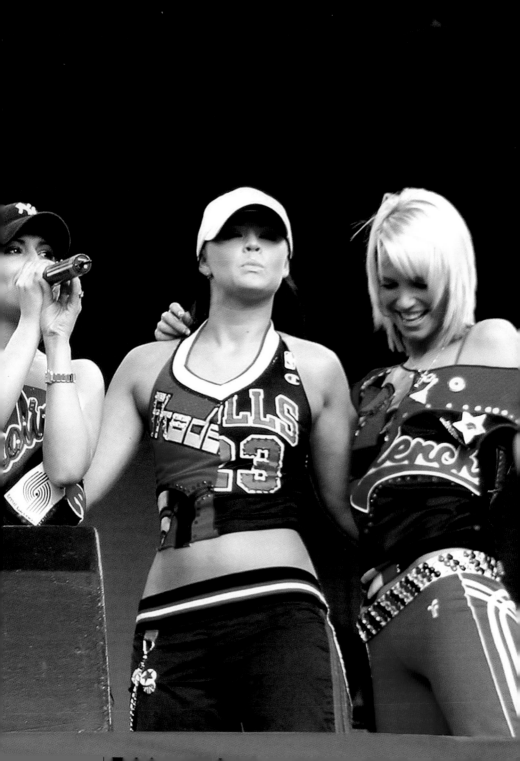

The legendary Che Guevara was called everything from a Romantic Adventurer, Red Robin Fellow to Communist Quixote and Worldly Jesus. On March 5, 1960, the shutter of Cuban photographer Alberto "Korda" Gutierrez captured one of the world's best-known images. The portrait of youthful audaciousness and idealism embodied in Guevara's disheveled hair and fervent eyes have become design elements of the most indelible influence.

Che Guevara was born in 1928. In the early years, he had been to every Latin American country. He went to Cuba in 1954 and in 1960, then visited China and Soviet Union as the head of the Cuban National Bank. The following year, as the third-highest ranked leader in Cuba, he went into the Bolivian jungle in the pursuit of a greater communist revolution. He declared his resignation from his positions in Cuba and promised no return. The famous guerilla leader was finally captured in Bolivia in 1967. After his death, Guevara became a martyr and symbol of radical youth movements around world.

Guevara's devotion to personal causes and defiance against the status quo was greatly worshipped by the young generation. He was a hero, an idol, and an icon. Guevara's appeal has transcended the political to the popular and his iconic image has become a pop symbol.

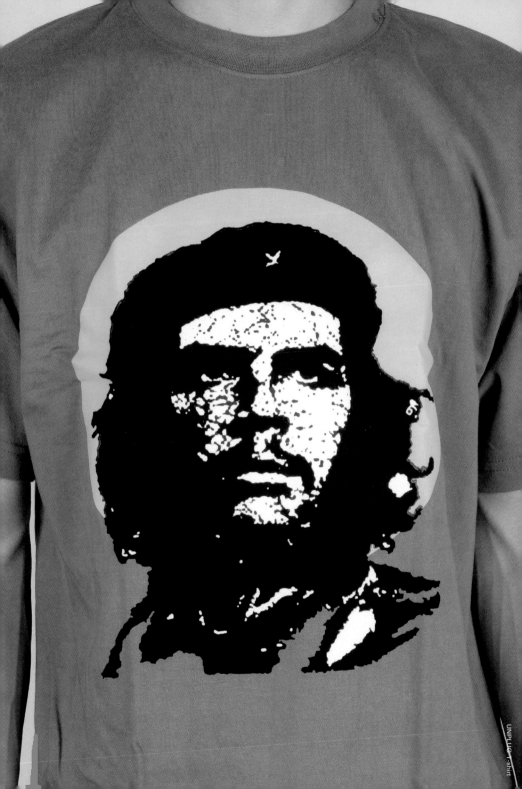
UNPLUG-T-shirt

Photo by Jane Mingay

When revolutionary or communist slogans appeared on T-shirts, the new generation of youths gave a twist to the "red" spirit. In cultural parlance, "I love Lenin" is equivalent to "I love Beckham;" words and images of Marx, Stalin, and Mao Zedong are printed on T-shirts as youthful expressions of cultural idealism. Even if today's youth do not know the meaning of "CCCP," they express their understanding of utopia and dream of building a new world.

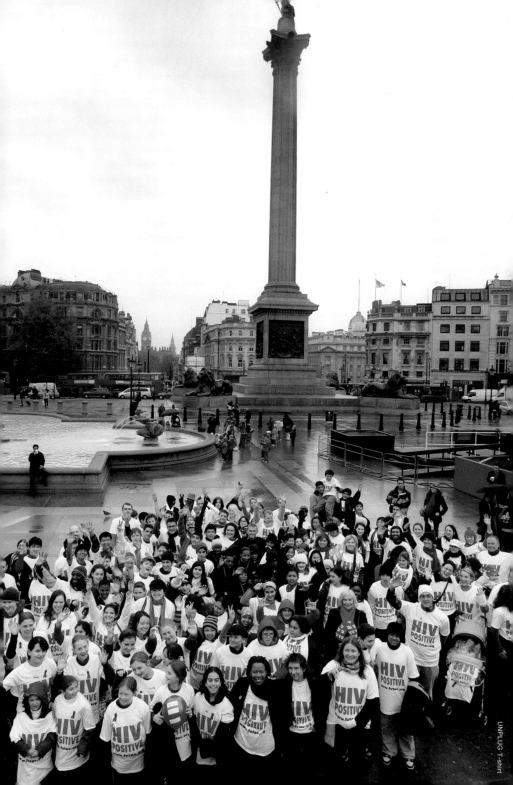

UNPLUG T-shirt

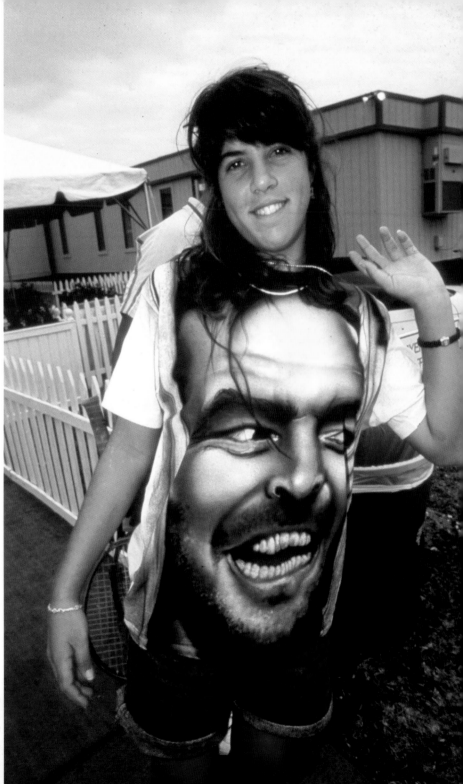

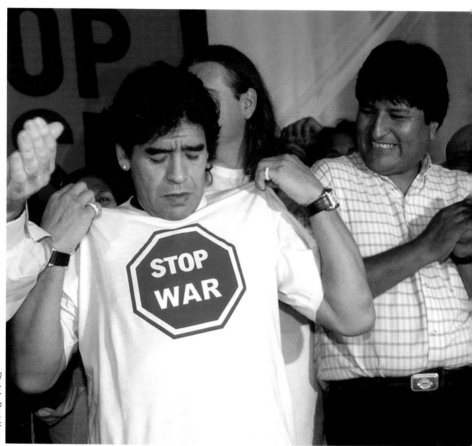

**083**
T-SHIRT

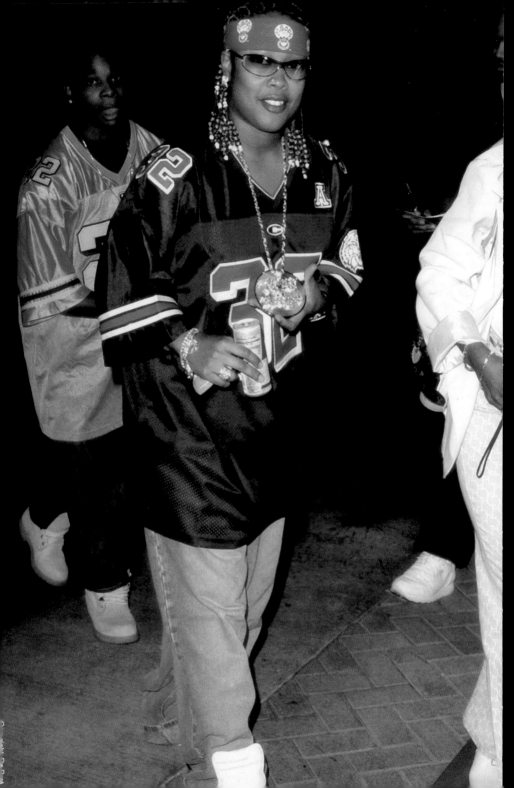

In 1993, a student from Pennsylvania State University wrote some mean and dirty words on some T-shirts and tried to sell them. To his surprise, they sold perfectly well and the company Andi was born. Today, Andi is associated almost exclusively with street basketball. NBA players including StephEn Marbury, Ben Wallace, and Jason Williams are all contracted brand spokesmen.

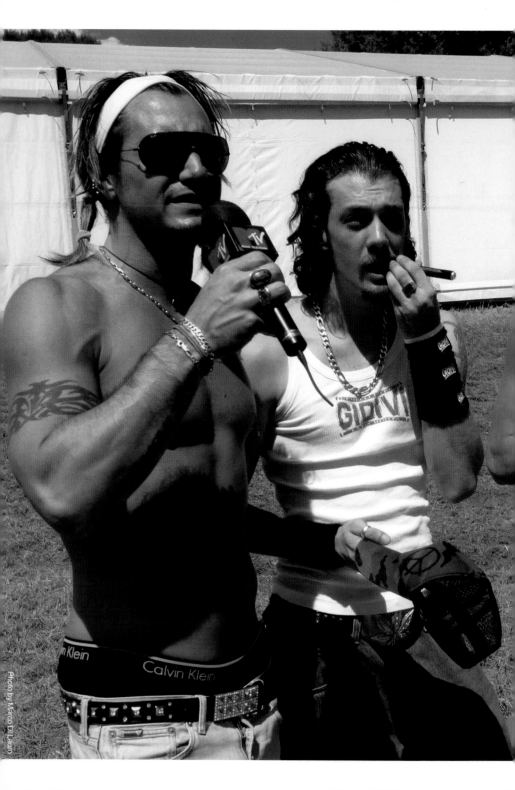

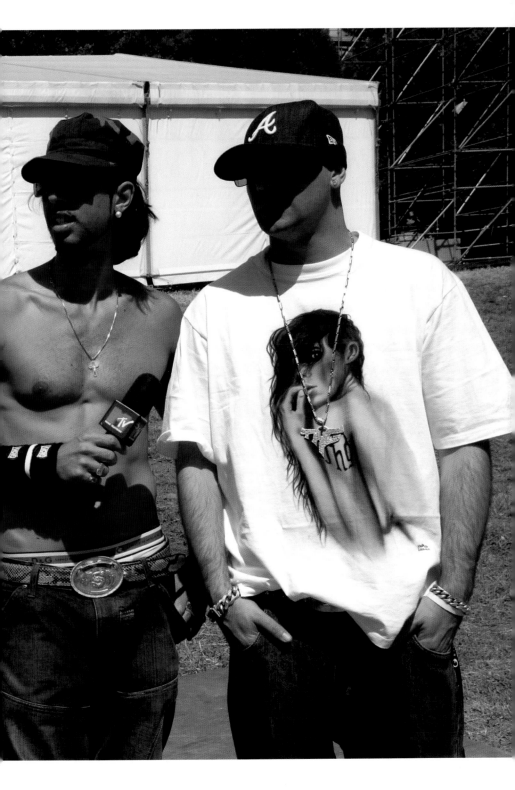

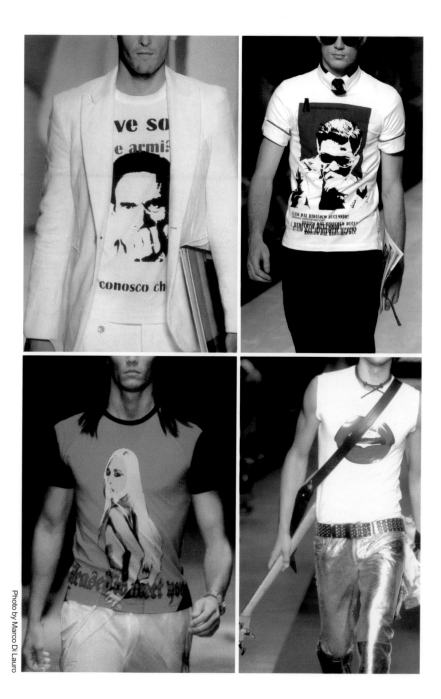

**088**
T-SHIRT

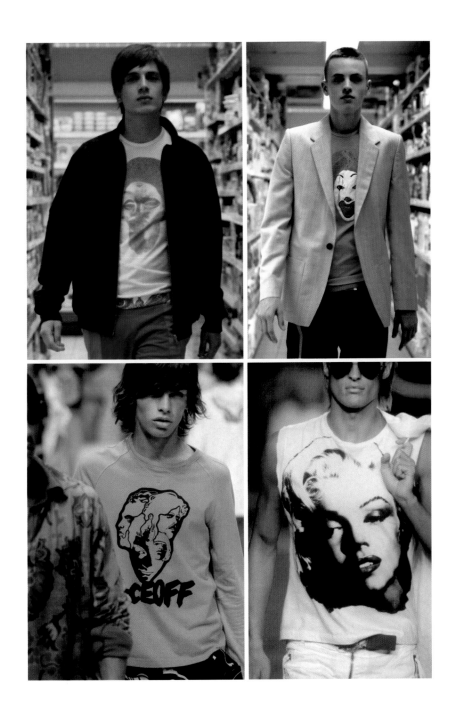

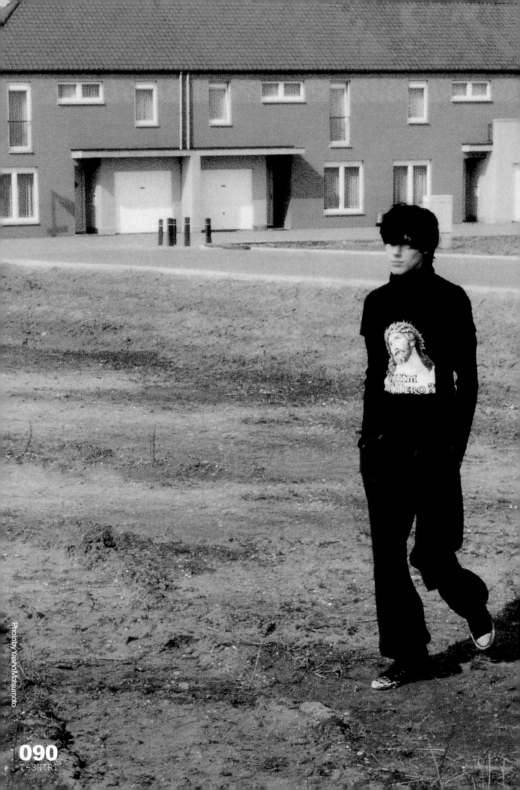

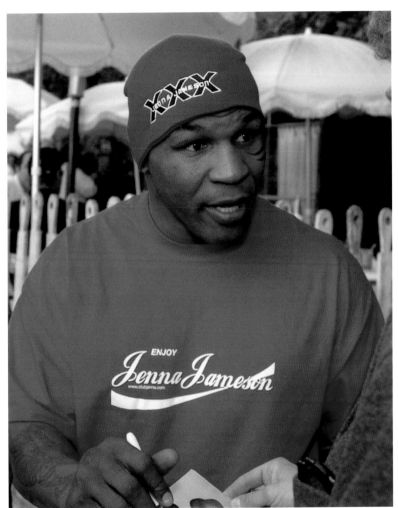

**091**
T-SHIRT

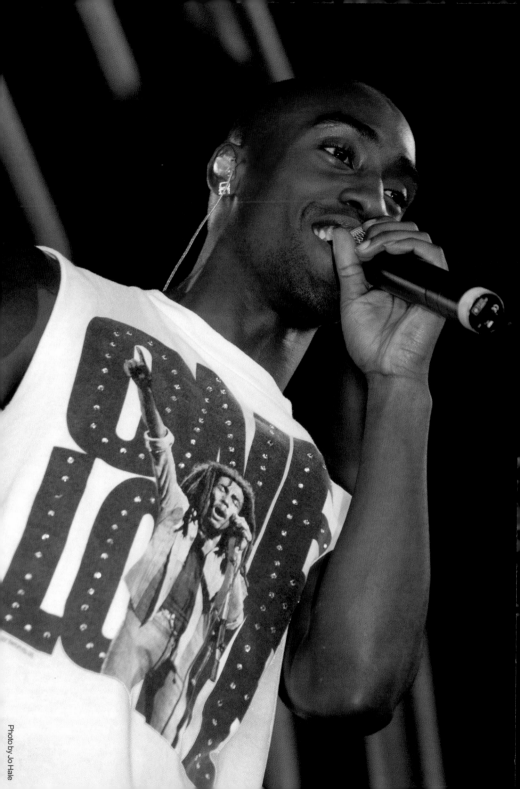

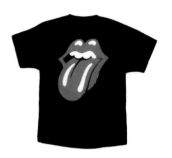
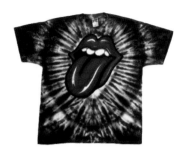

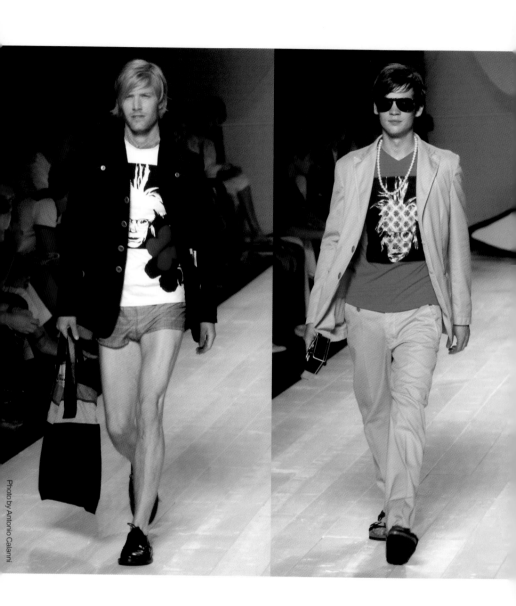

**094**
T-SHIRT

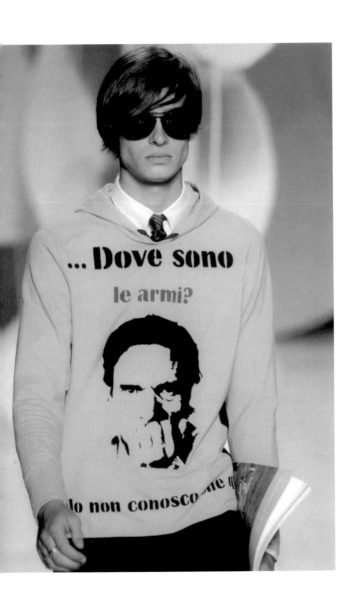

# Art Duplication

3

Artistic T-shirts are an enterprising way to showcase original art and an excellent way to increase its visibility. For some artists, they can be a low-cost shortcut to advertising their work. In fact, art galleries including Le Centre Pompidou in Paris have begun to collect these original T-shirt designs. Different from simple screen printing, artistic T-shirt design is considered art that conveys an aesthetic appeal. It exists between art and commerce and sometimes can be very lucrative.

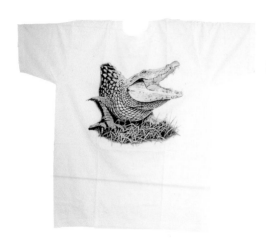

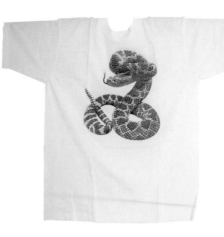

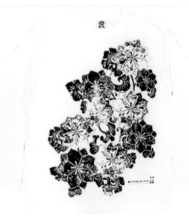

**100**
T-SHIRT

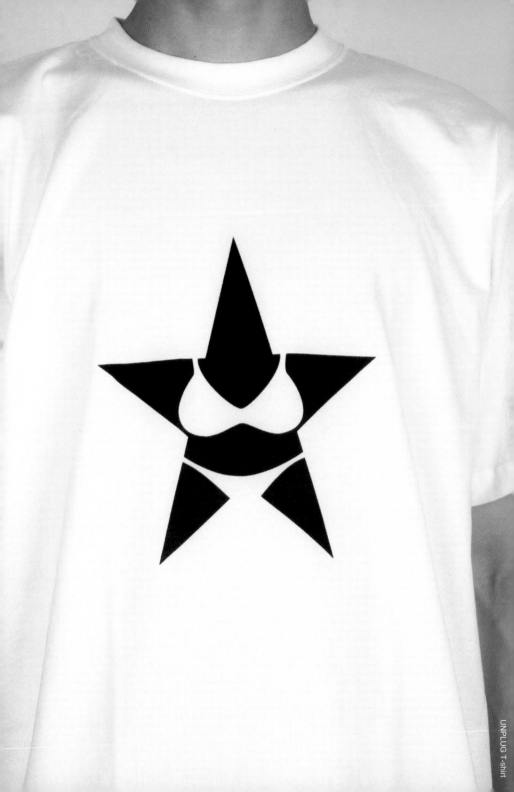

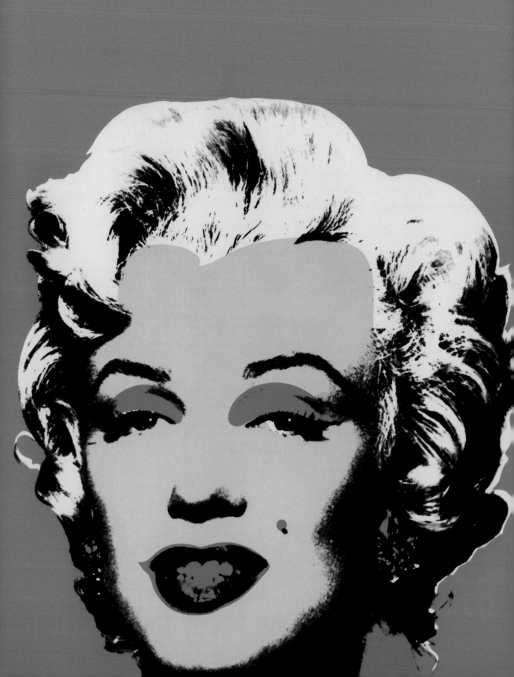

This is Pop Art. The term was first uttered by British commentator Laurence Alloway in 1956. Aiming to turn abstract art into substance, Pop Art is a kind of inexpensive, mass-produced, young, interesting, commercial, spontaneous, and transient spirit and style. It is also sarcastic. To put it simply, Pop Art is a revisited form of the low-end art market.

 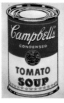

One of the founders of Pop Art, Andy Warhol, frequently used serigraphy printing and is known for his tiled, repeated subjects, such as Marilyn Monroe and Campbell's soup cans. Warhol's works represented the American culture of the '60s and were used on T-shirts, inspiring contemporary-themed interpretations, such as the repeated images of the hamburger, Che Guevara, and even George W. Bush.

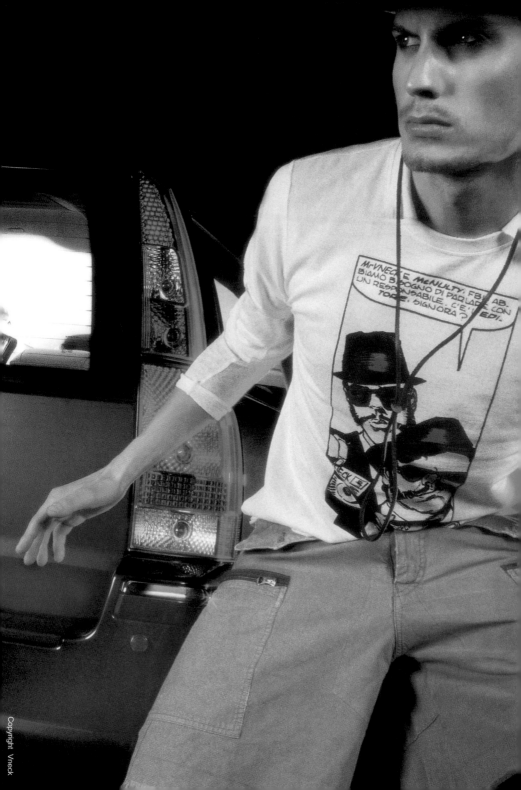

Another Pop Art master was Roy Lichtenstein, who imitated cartoon-style illustrations by duplicating them from paper to canvas with paint or propylene. Colors and lines were precise and the dots were clear. This technique allowed a touch of paint on the printing screen and they were duplicated onto a larger scale or adapted onto modern T-shirts.

Bold, contrasting colors are characteristic of Pop Art, and these are perfect elements for T-shirt design. From a technique angle, strong contrasting colors and lines meet the printing requirements. Nowadays, portraits of politicians and pop stars are printed on T-shirts, and they are deliberately distorted to make it humorous and fun—another kind of aesthetic of T-shirt design.

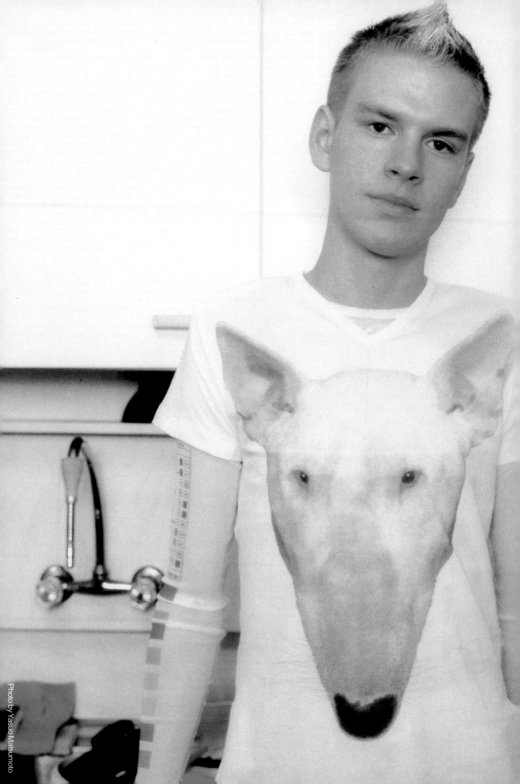

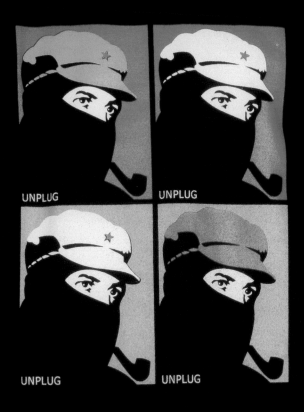

UNPLUG    UNPLUG

UNPLUG    UNPLUG

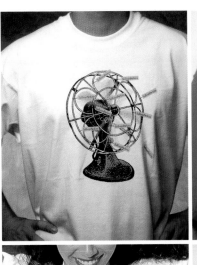
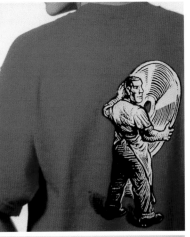
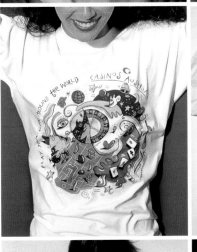
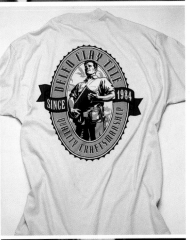
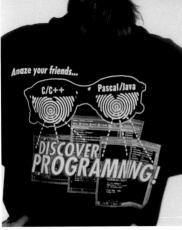
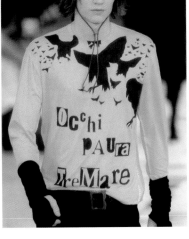

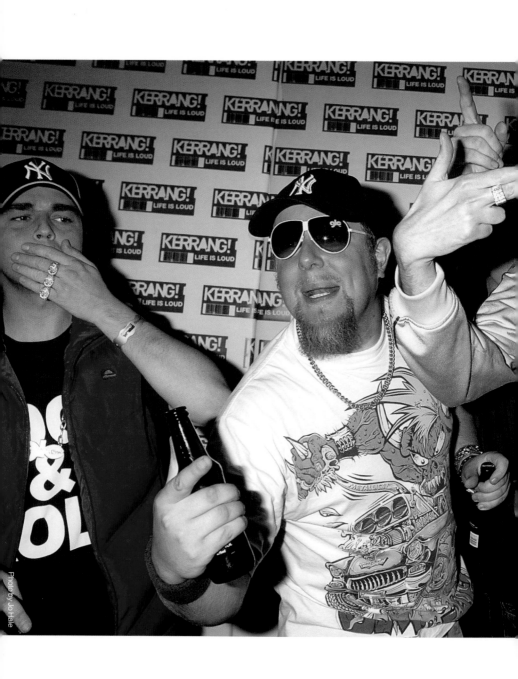

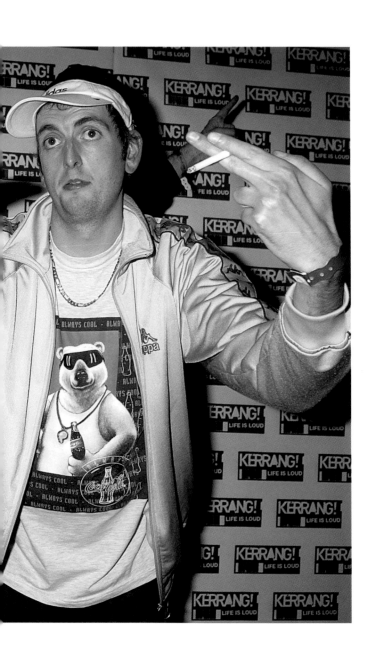

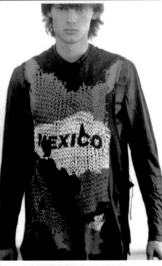

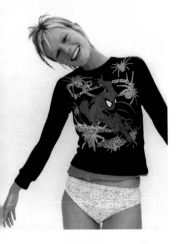

Both graffiti and T-shirts are products of urban society. Graffiti is closely related to the success of Pop Art in the '60s and is considered a natural extension of the Pop movement. The famous Pop artists were only a small group of elites who had received professional training. Graffiti artists were part of a subculture and were largely self-taught. Because of their typically young age, their works naturally showed a touch of innocence. They were simple, naive, and appealing, although sometimes rough and primitive. Unlike other art forms, most graffiti works were not preserved. Graffiti artists had to play games with the police while at the same time finishing one's masterpiece on the wall. In order to drive the "vandals" away, police wired the wall with electricity, which finally caused death of one artist in New York City. After the surge of outrage in the community after the incident, the city officials finally reached a compromise.

Graffiti was moved to an exhibition center in downtown New York and was finally acknowledged as a means of artistic expression. Meanwhile, art pieces turned up at auctions. One piece by Keith Haring was sold for $350,000 (in U.S. dollars). In stores, T-shirts featuring works by Haring were also bestsellers. In Hong Kong, calligraphy painted by a renowned graffiti artist sold for $55,000 (in HK dollars) at a Sotheby's auction.

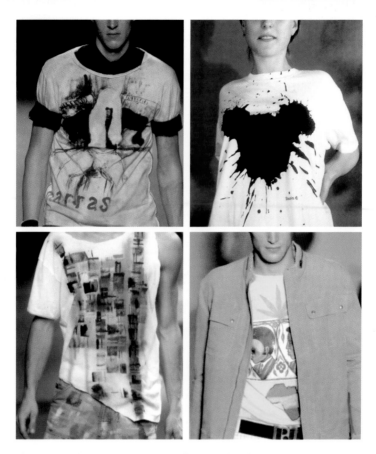

The '80s saw the explosion, then gentrification, of graffiti. Street artists who once evaded the police became gallery artists. Even graffiti on T-shirts was highly priced. The most successful graffiti artist turned businessman was Marc Ecko, who started as a graffiti artist while still in college and went on to create a line of six original T-shirts designs. Now, Ecko is the owner of Ecko Unlimited, and the brand's is worth billions of dollars. The legendary artist and businessman once said, "What we want is attractive, exaggerated, shiny, and even astonishing designs that will meet the young people's desire."

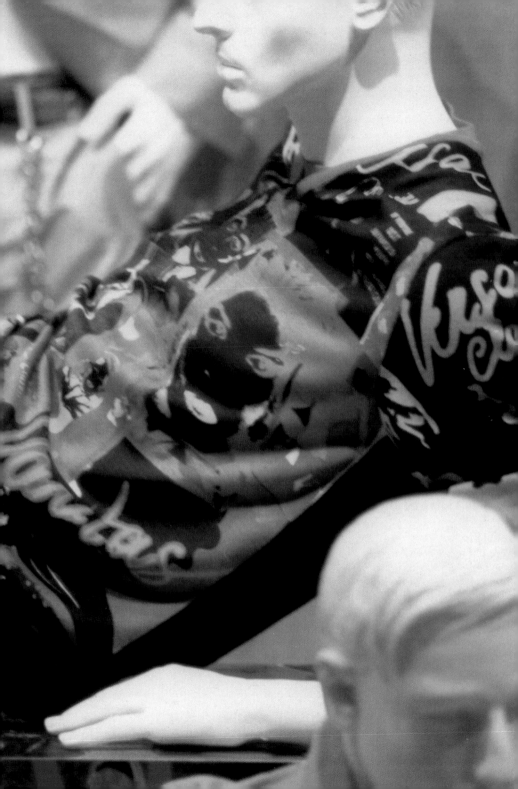

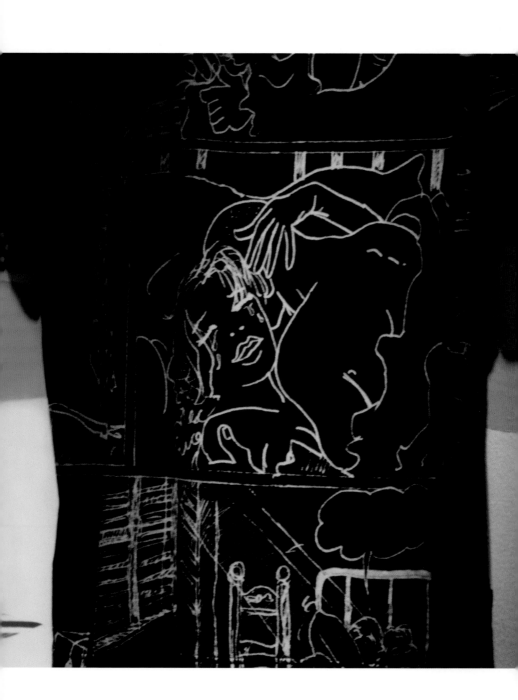

**121**
T-SHIRT

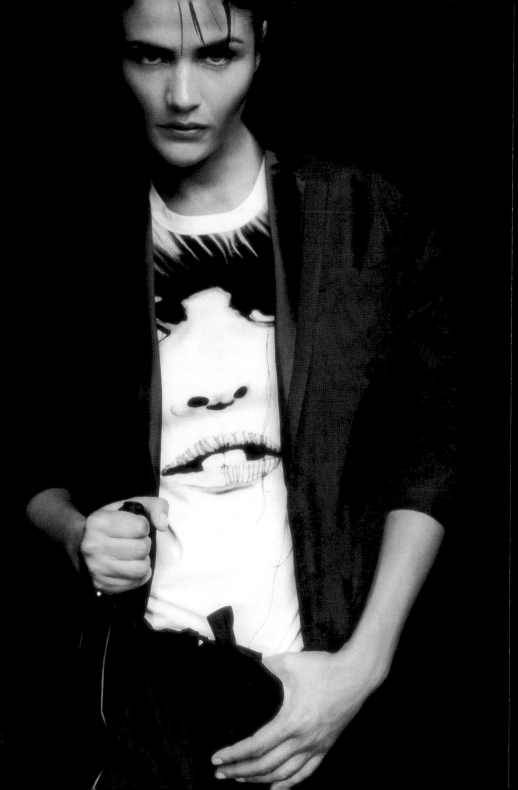

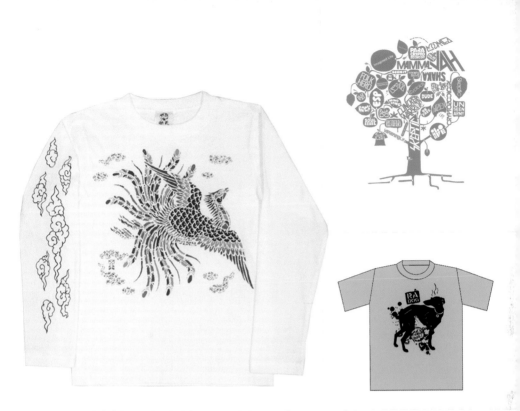

Most graphics and words are printed on T-shirts. However, just as photographs can never take place of hand drawings, handmade T-shirts still have cachet. In Europe and America, hand-drawn T-shirts are usually made with propylene spray. In New York City, a high-end hand-drawn T-shirt can be sold for more than $100 (in U.S. dollars) and many professional illustrators prefer to draw on T-shirts to create more of their art pieces.

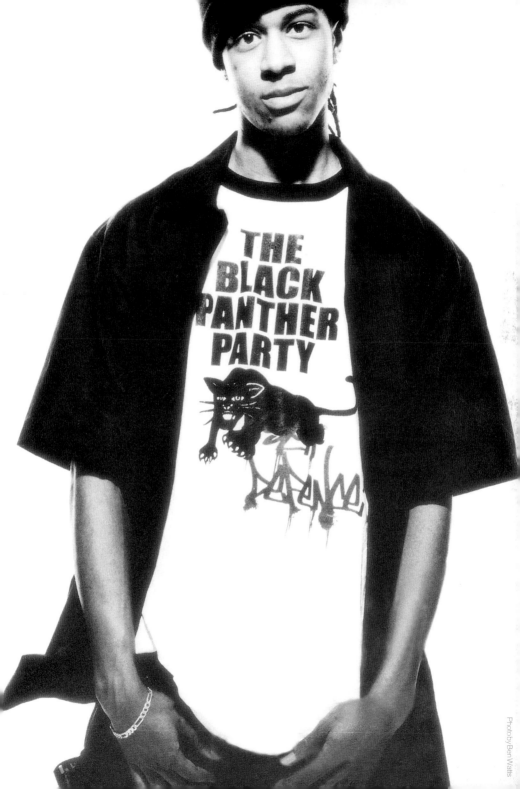

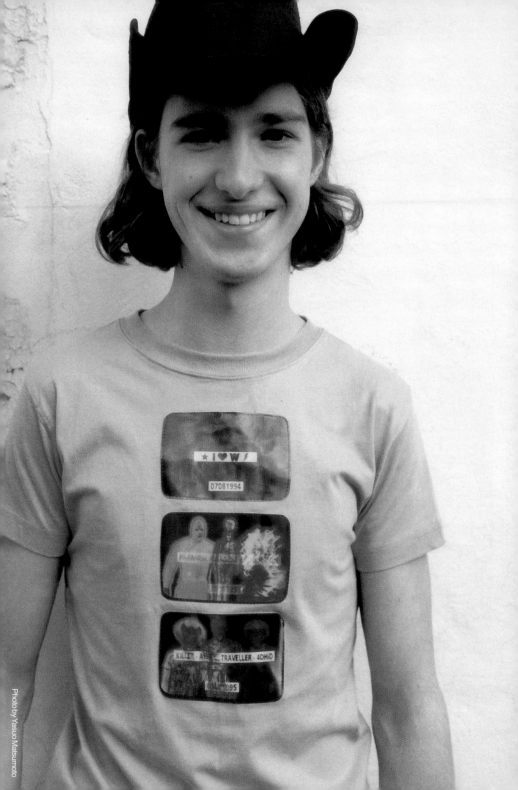

The subjects of hand-drawn T-shirts can include everything from nature scenes to cultural icons. Because it is more difficult to draw on T-shirts than on paper, these T-shirts are generally priced higher. With the boom of the cartoon industry, cartoon images have become another subject for T-shirt art.

The simplest way to create T-shirt art is to draw on a white T-shirt with a marker pen, or with paint or propylene. In order for the design to be durable and permanent, it should be heated to dry after painting.

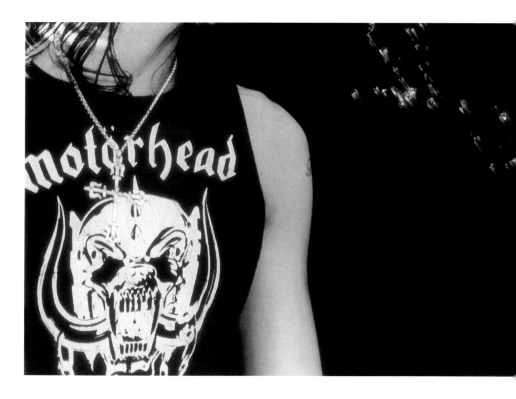

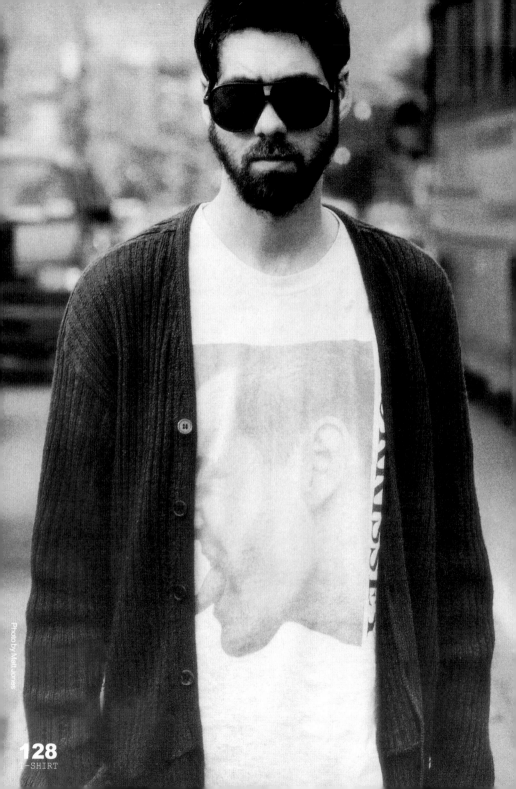

Photo by Matt Jones

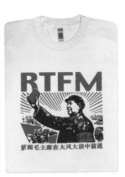

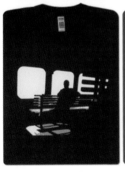

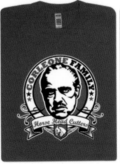
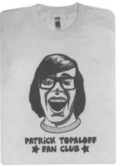

# Chinese Elements

From the traditional Chinese dragon to Beijing Opera faces, from Spring Festival paintings to folk scissor cutting, T-shirt design is taking into consideration traditional Chinese culture. Chinese imagery has been prominent in recent years, from the popular Monkey King to beret-toting Mulan. In addition to figures from legend, traditional Chinese paintings have also been put on T-shirts.

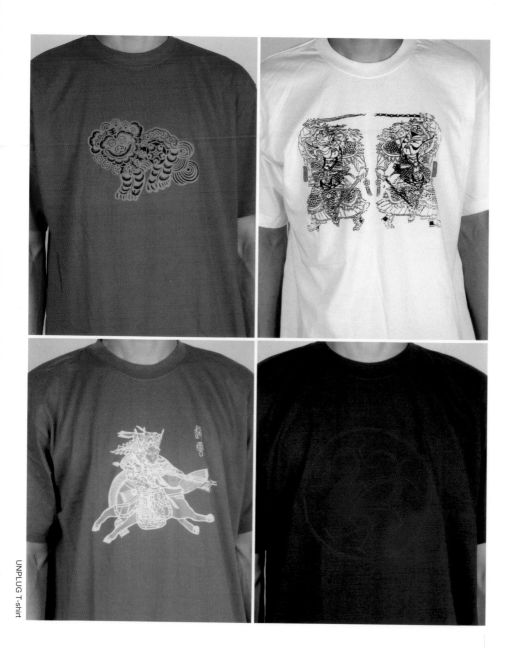

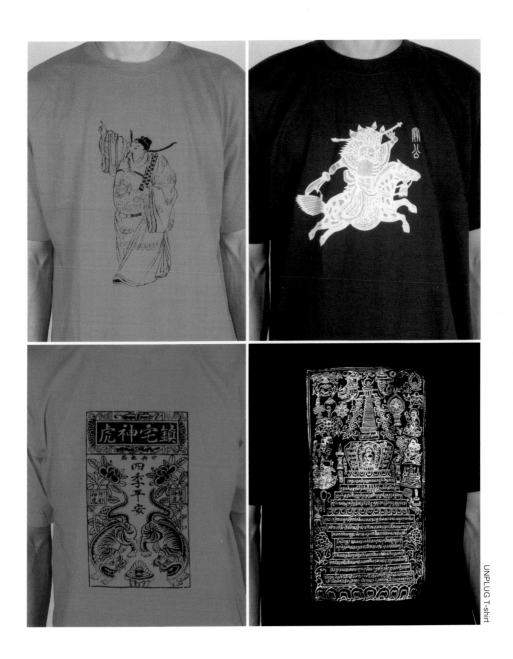

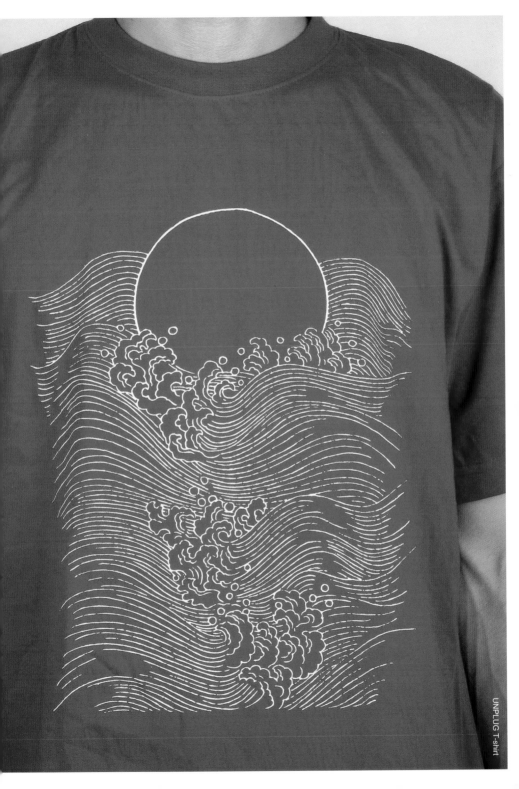

UNPLUG T-shirt

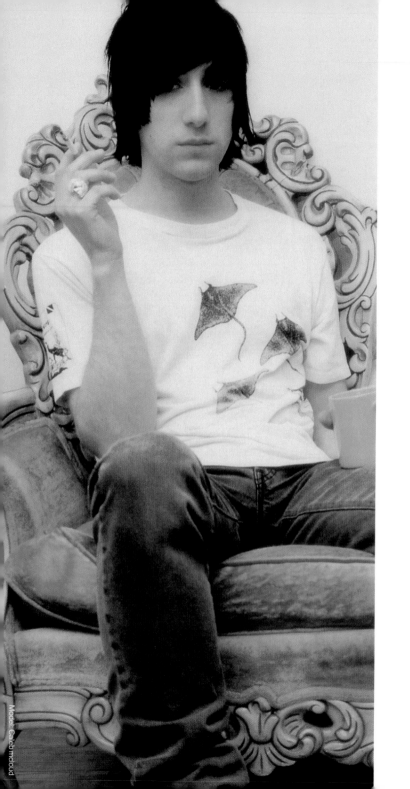

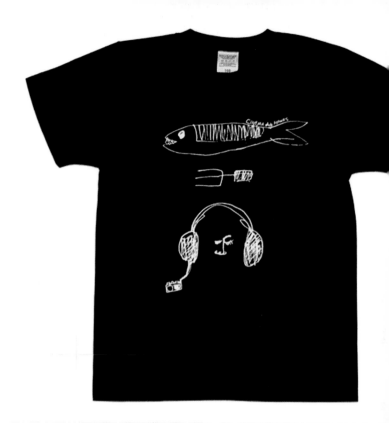

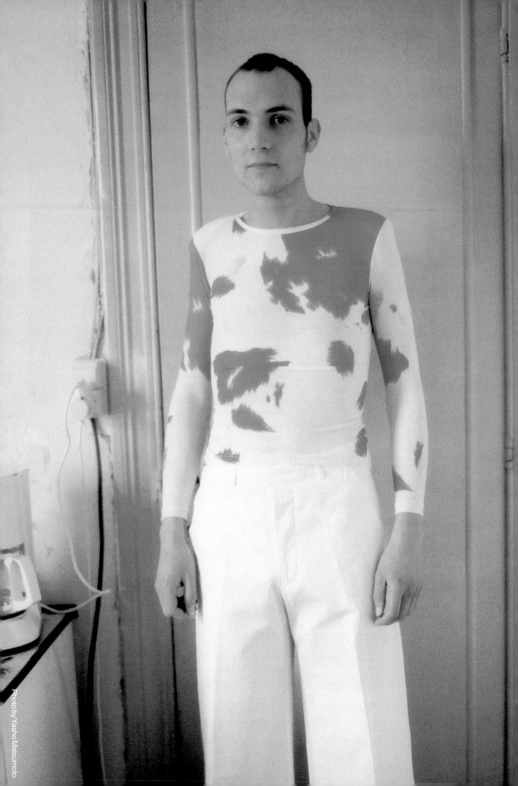

Tie-dyeing originated from cultures in the Sahara and the Chinese started using it during the East Jin Dynasty era. During the Tang Dynasty, it began to be widely used. Using natural pigments, tie-dyeing creates a wide array of patterns. Before dyeing, T-shirt fabrics are folded, rolled, twisted, and bound, then placed in jars of dye, in order to achieve multicolored layers of color. Because of this technique, the final color patterns graphics are unexpected and unique.

In the 1960s, the unexpected colors and patterns of traditional tie-dye were "rediscovered." Under the influence of ethnic style and a resurgence of vivid color in fashion, tie-dyed T-shirts were adopted as a mainstay trend.

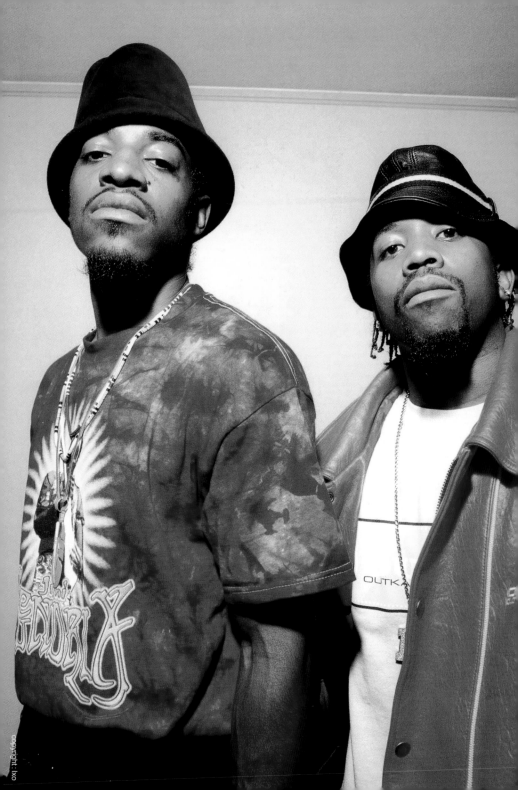

Tie-Dyeing Instructions

To create graphics on your T-shirt, first, draw design in pencil and then cover the picture with plastic. Loosely wrap a cotton rope around the T-shirt. For a circular pattern, pick up the T-shirt from the front and center section and wind the rope around it tightly. Twist the T-shirt, bind with ropes or rubber bands. Pour the separate colors of dyes into separate pots. Put some salt in the dye mixtures in order to make the colors bright. Put the twisted T-shirt into the pot, and boil for half an hour. Remove the T-shirt, unwind it, and rinse in cold water. Voila, a DIY T-shirt is finished!

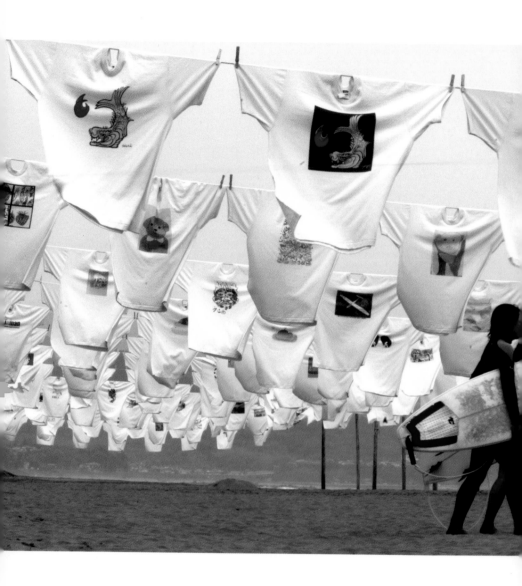

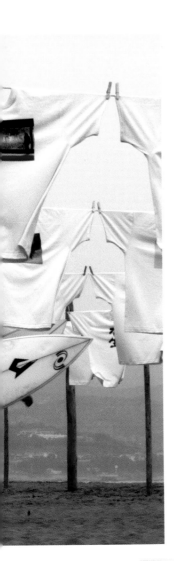

"Photographic and picture exhibitions should only take place indoors." No attention was paid to such conventional thought, and the first outdoor art exhibition in the world was held at Cochin, Japan. T-Shirts were the canvas. Organizers drove sticks into the ground, attached ropes to them like clotheslines, and hung up T-shirts as though hanging laundry out to dry. As waves lapped the shore, the T-shirts' colors were reflected on the beach. When the wind blew, the T-shirts began to dance. Even rain did not cause a problem. Organizers suspended hundreds of T-shirts and created a one-of-a-kind installation of "Modern Art," known as the Seaside Gallery.

# Declaration

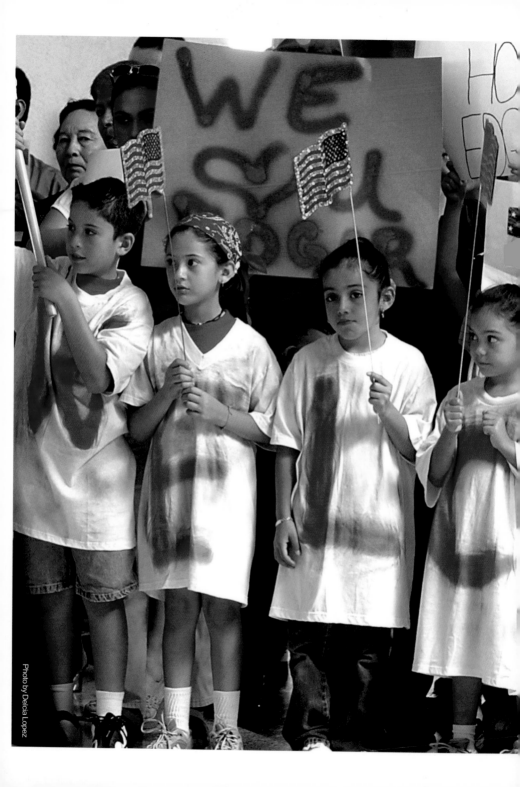

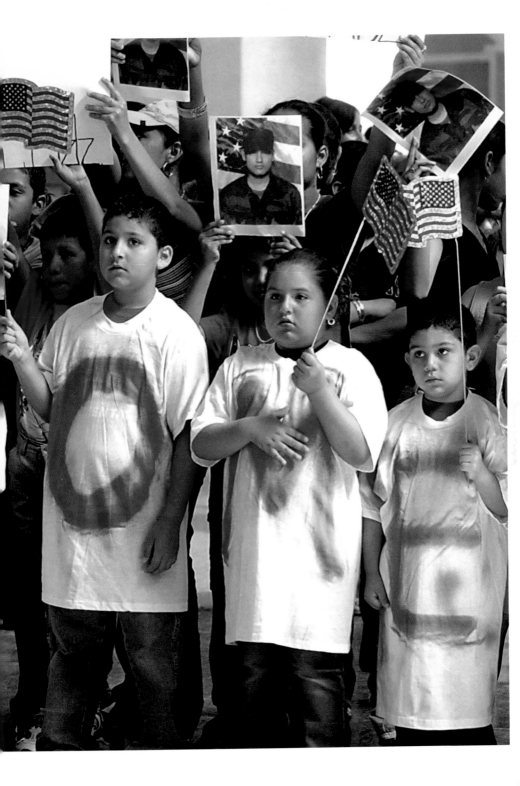

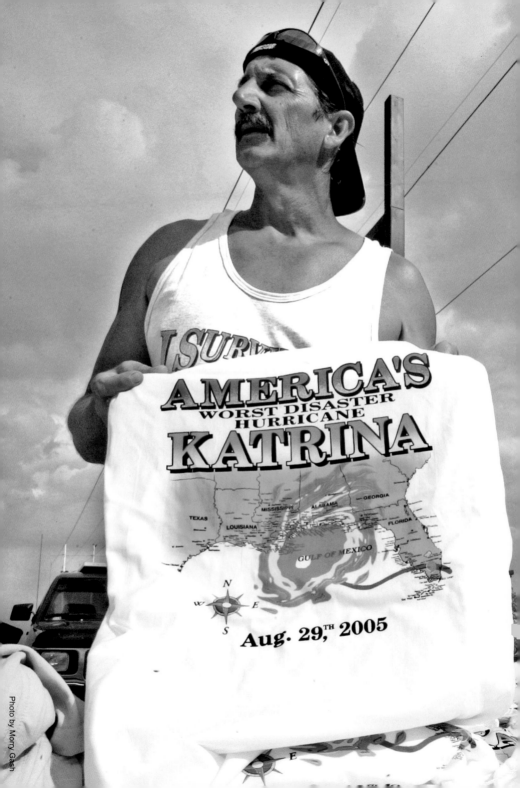

Who will God vote for? Look at T-shirts. In 2004, supporters of John Kerry wore T-shirts that said: "No Bushit," "Who Would Jesus Bomb?," and "No CARB" [Cheney, Ashcroft, Rumsfeld, and Bush]. When the time came for France to vote for the EU Constitution Agreement, people wore *oui or non* on their T-shirts to express their attitudes.

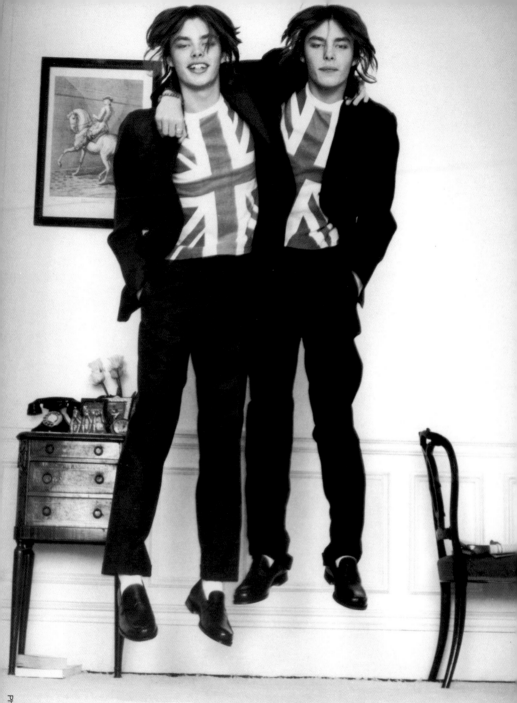

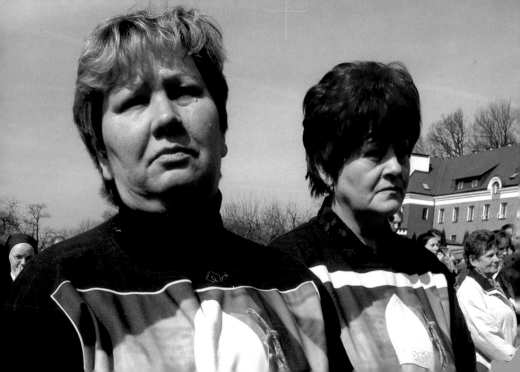

Photo by Vassil Donev

In a competitive match, fans show their support with T-shirts. In the Davis Cup match between Australia and Argentina, Australian supporters were dressed in yellow T-shirts.

When Manchester United met Arsenal in the FA Cup final, the words on Manchester United fans' T-shirts were "You will never buy me." This was the silent protest towards the controversial selling of the club. On the contrary, Arsenal fans wore T-shirts that said "Not for sale." When the club sold off its 75 percent stock to the "American Oil Crocodile," no one could believe it. In that match, some wore black T-shirts that said "No customers, no profits," and held a big banner with the words "RIP MUFC 1878-2005."

The T-shirt is the most direct weapon for protestors. Wearing them, protesters shouted at the camera, garnering attention for their causes.

The G8 summit is the annual meeting of the leaders of Canada, France, Germany, Italy, Japan, the United Kingdom, the United States, and the Russian Federation. It is also a key, high-profile summit for protestors who rail against globalization and free trade, and its ravages against developing nations. At this summit, protesters are no less eye-catching than presidents and prime ministers. In recent years, protestors have been angry at the United States for ignoring United Nations' protocol and for the Iraq War. Some slogans read "Give Peace a Chance," and the more aggressive "Bush, The Biggest Terrorist."

DON'T

GIVE ME YOUR NEWS PAPER HEADLINES!
YOUR CNN NEWS TO HAND CRISIS TENSION MOUNTING
DON'T TELL ME THAT WE NEED ANO' WAR!

FUCK WAR
NO WAR!

UNPLUG T-Shirt

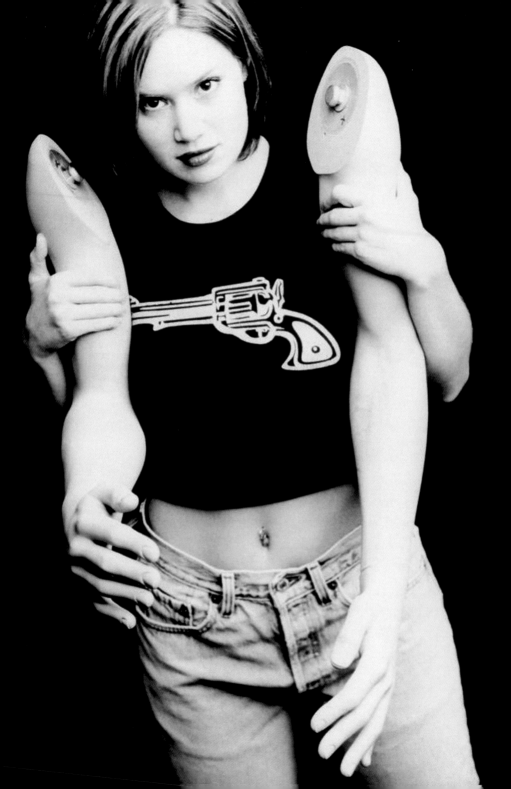

On the catwalk, fashion designers use T-shirts to express their views, with the help of models and celebrities. During the anti-Vietnam War movement, designers and celebrities marched together in protest. John Lennon's song, "Give Peace a Chance," was released, and the simple T-shirt became a banner calling for peace.

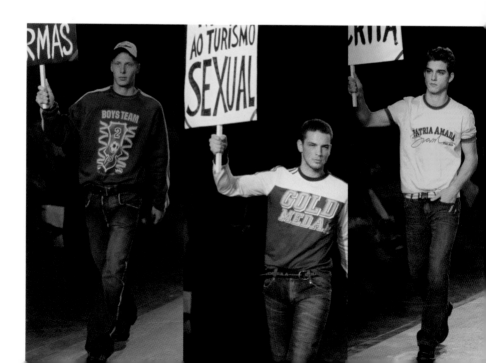

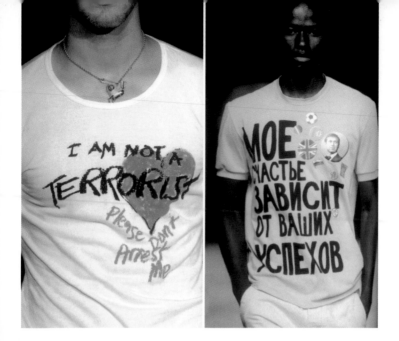

Black and vintage styles reigned during the 2003 London Fashion Week, however anti-war T-shirts were the most eye-catching. British street fashion queen Katharine Hamnett put "Stop War Blair Out" and "Stop War Email Your MP" on T-shirts worn by models. This was not the first time Hamnett expressed herself in this way. Back in 1985, in the presence of Margaret Thatcher, she wore a T-shirt saying "58% don't want Pershing," which quite embarrassed the then-Prime Minister.

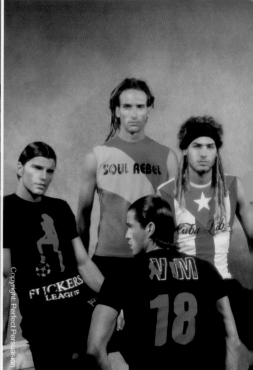

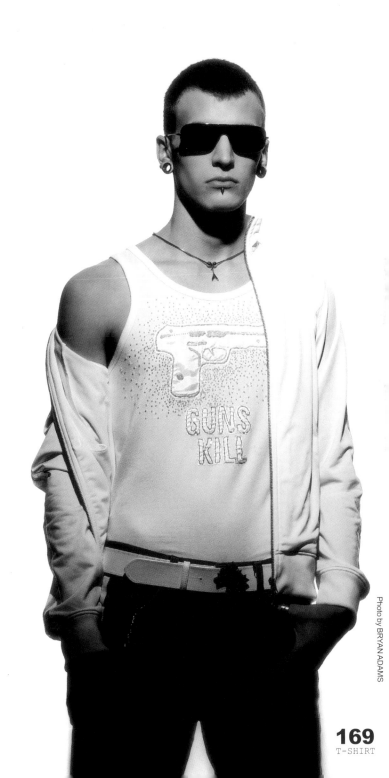

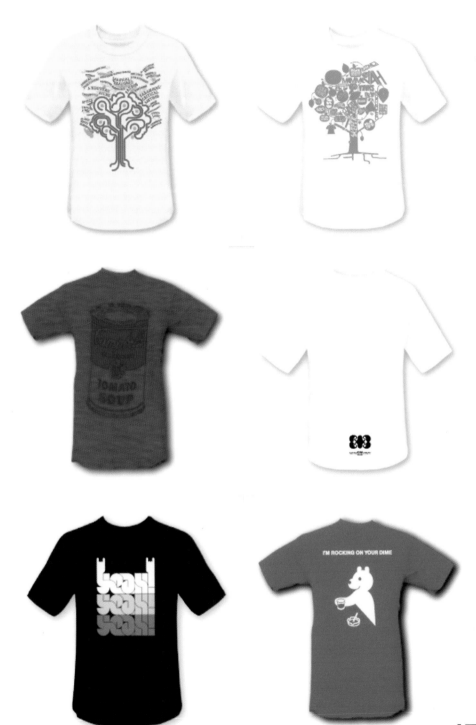

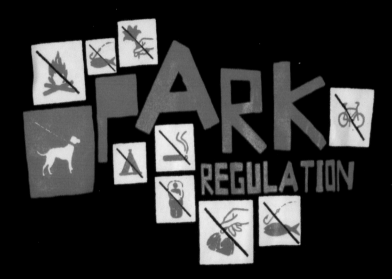

PARK REGULATION

In July 2004 in Australia, more than twenty Greenpeace members followed Australian Prime Minister Howard, wearing T-shirts that pleaded with him to not give up on the Kyoto Protocol. This was the protest against Australia's rejection to sign the protocol. On February 16, 2005, the Kyoto Protocol was officially ratified. Meanwhile, members of Greenpeace celebrated worldwide by wearing "Solar Generation" T-shirts.

PILGRIMS CROSSING

to be free.

see you on the
other side.

final solution

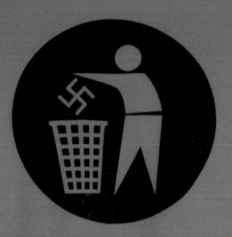

Keep our country clean

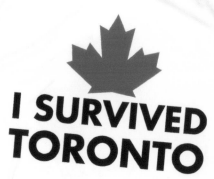

# I SURVIVED TORONTO

- ☑ SARS
- ☑ WEST NILE
- ☑ MAD COW
- ☑ SARS (again!)

TM

The boy trademark by UNPLUG

TM

The dog trademark by UNPLUG

trademark™
everything™

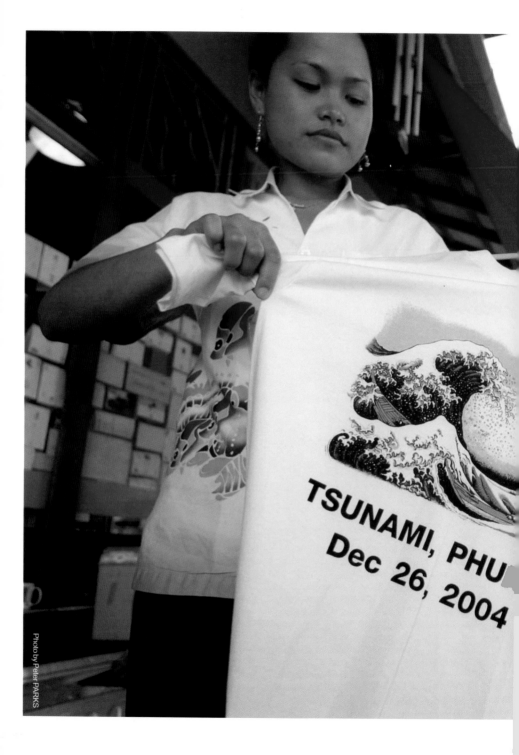

TSUNAMI, PHU
Dec 26, 2004

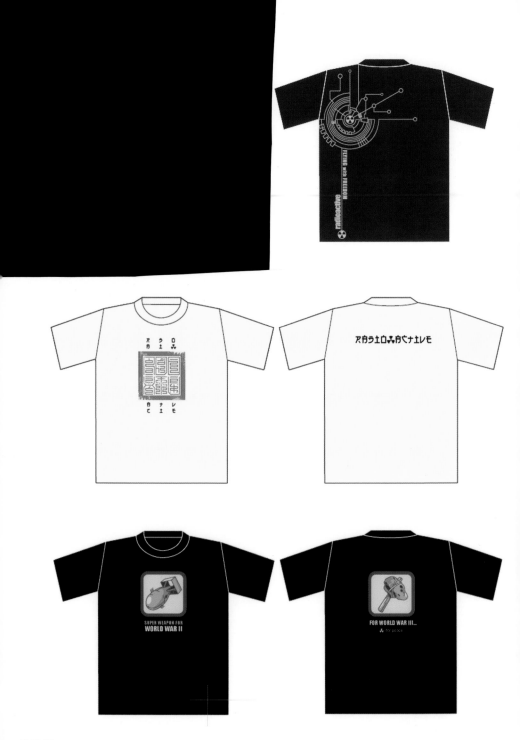

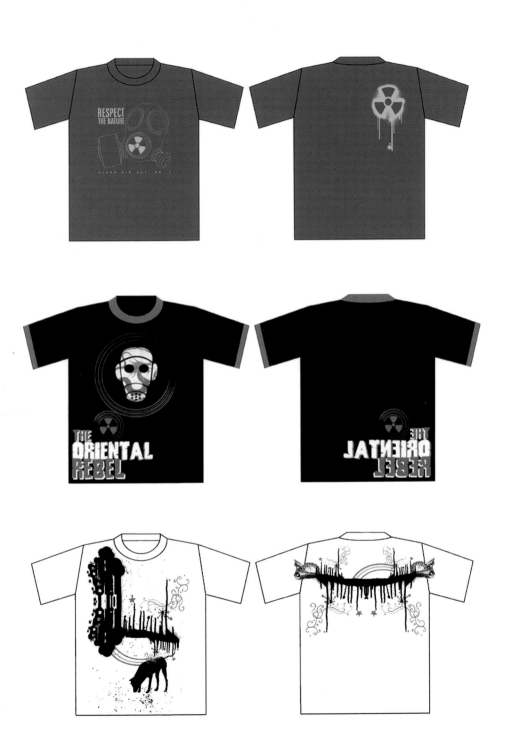

**181**
T-SHIRT

# Mobile Posters 5

Business people learned, eventually, that T-shirts are not only a form of merchandise to be sold, but they are also a mobile, versatile advertising tool. Often, T-shirts are given away free of charge, distributed at a party, or a commercial activity. Those T-shirts are designed to be worn once, as part of an advertising campaign. The United States produces billions of T-shirts each year, with T-shirts created for advertising purposes taking up a large part of that figure.

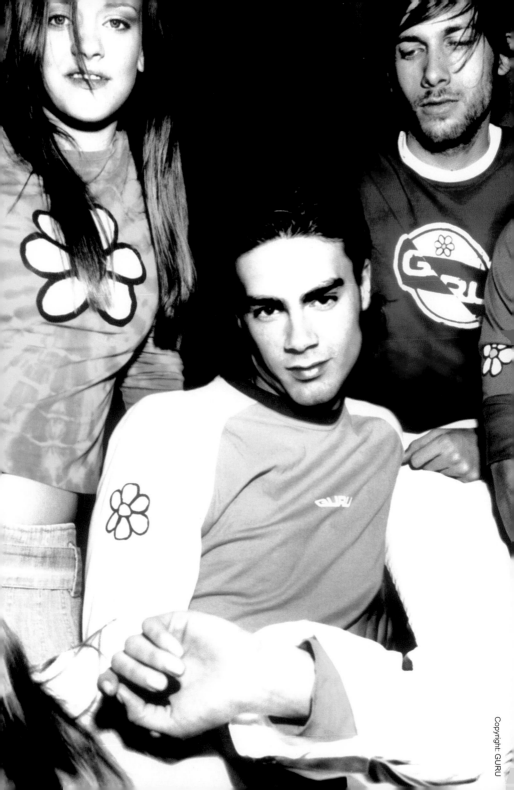

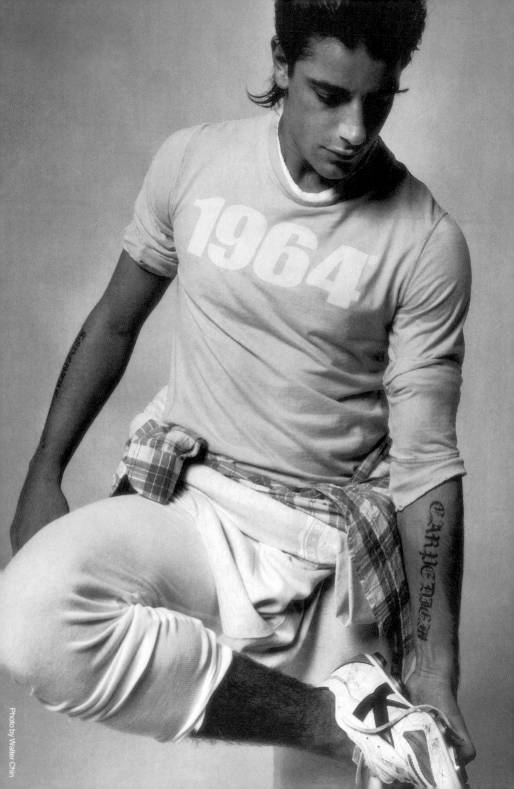

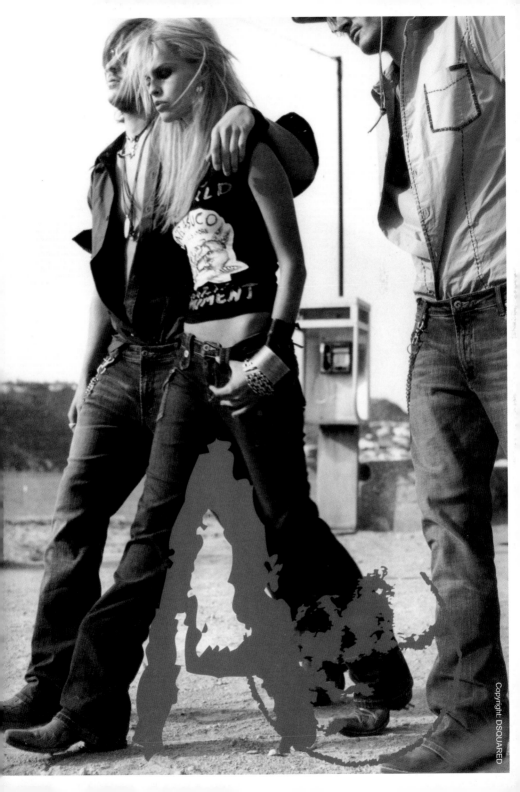

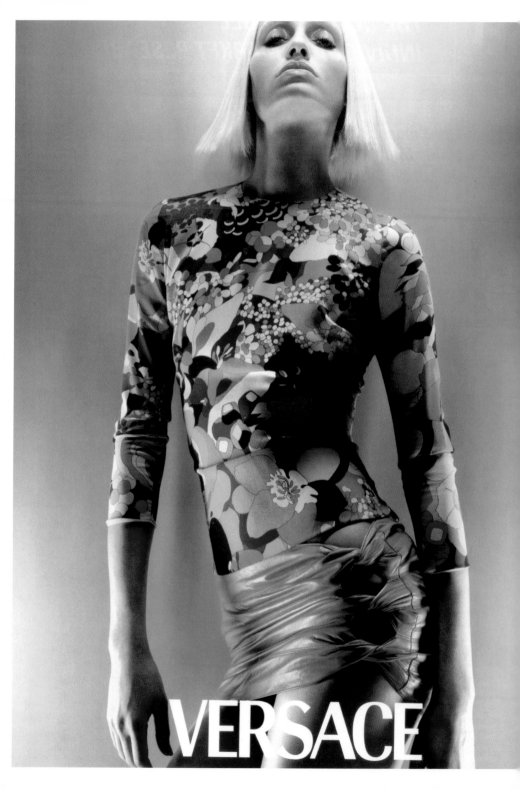

VERSACE

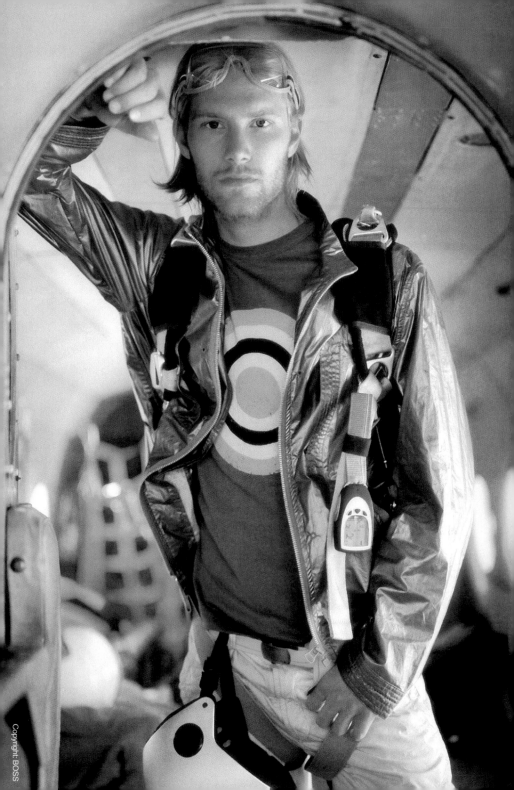

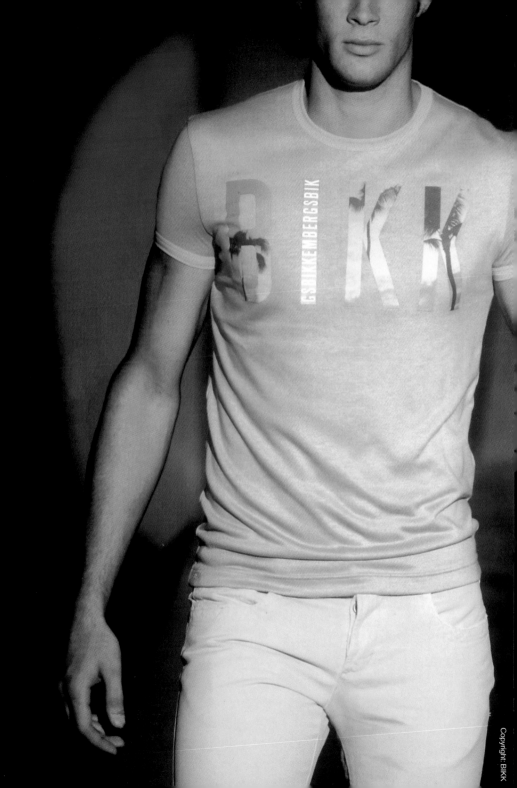

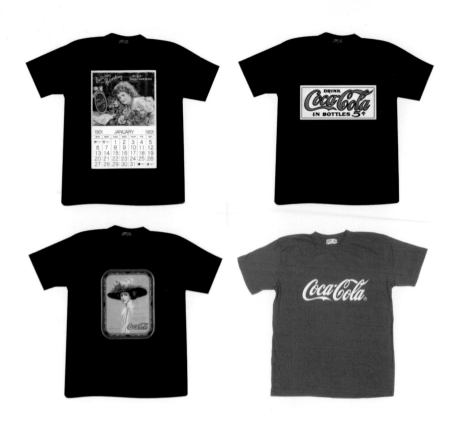

In 1886, the first bottle of Coca-Cola was sold in the United States. Once sold as a "temperance drink," which was purported to be a cure for many diseases, the drink soon conquered the world. T-shirts with red Coca-Cola logos have always been a symbol of American culture; it seems no one minds doubling as advertising billboards! Logos of beers are printed on tight-fitting T-shirts for waitresses to wear while working, in the hopes that it will sell more of their brand. During concerts, a T-shirt with the performer's signature usually comes with the more expensive tickets. These T-shirts are concert memorabilia, and help boost the venue's atmosphere.

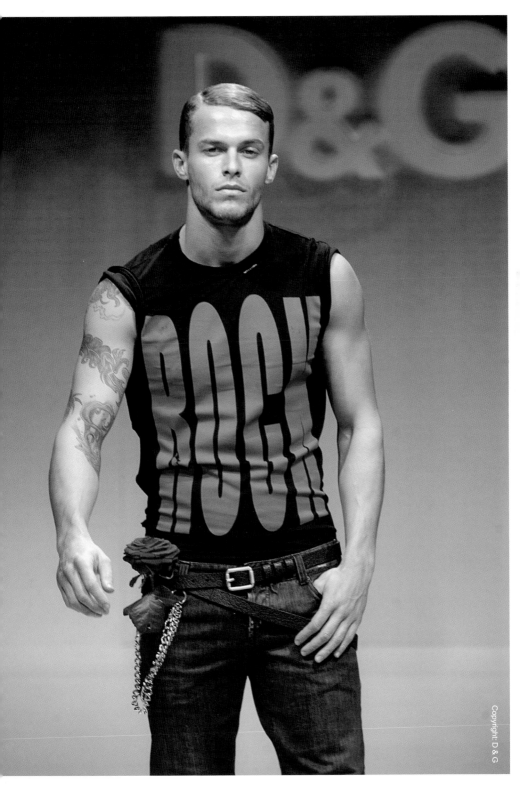

When the film *Harry Potter and the Chamber of Secrets* was released in November 2002, small children in Harry Potter T-shirts swarmed to cinemas. Movie T-shirts are a common sight; by manufacturing them, the film is promoted, and sponsors reap advertising profits. Soon after Mickey Mouse was created in 1928, Disney sold the image at for $3,000 (U.S.) to a stationery company. From there, Disney merchandising bloomed, and T-shirts with Disney characters are the bestsellers in Disney theme parks around the world. In 2005, a new Disney T-shirt series was launched; images included Snow White and the Seven Dwarfs, Cinderella, and Sleeping Beauty. Among them, the limited versions were snapped up by Disney fans; every year there are only eighty pieces produced.

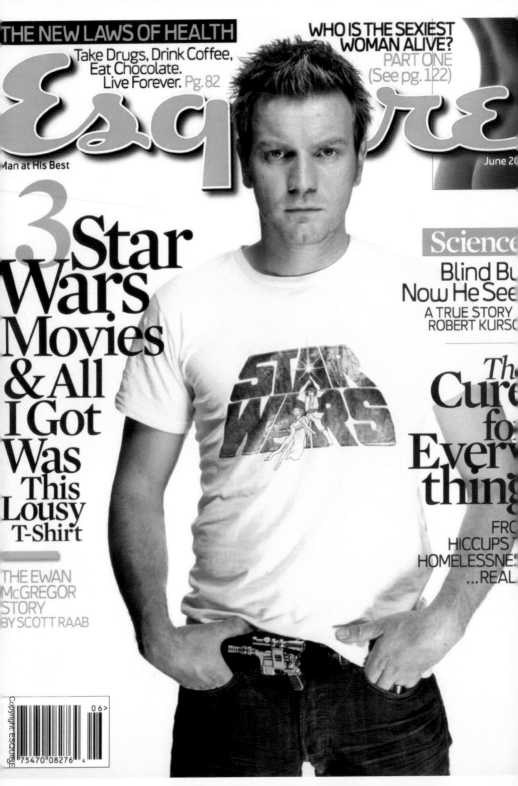

THE NEW LAWS OF HEALTH
Take Drugs, Drink Coffee,
Eat Chocolate.
Live Forever. Pg. 82

WHO IS THE SEXIEST
WOMAN ALIVE?
PART ONE
(See pg. 122)

# Esquire

Man at His Best

June 20

3 Star
Wars
Movies
& All
I Got
Was
This
Lousy
T-Shirt

THE EWAN
McGREGOR
STORY
BY SCOTT RAAB

Science
Blind Bu
Now He See
A TRUE STORY
ROBERT KURSO

The
Cure
fo
Ever
thing
FRO
HICCUPS
HOMELESSNES
...REAL

In 2005, T-shirts of computer game WOW gained popularity before the game itself was even officially launched. In Japan, Korea, and USA, the affiliated commercial value of a computer game is a few times more than the value of the game itself. Apart from online selling, game products are also sold at franchised stores; among these products, the T-shirt is the best-selling one. At first these products were sold as publicity gimmicks, and as the game gained more popularity and attracted more consumers, their value increased and they gradually turned into commercial products.

**202**
T-SHIRT

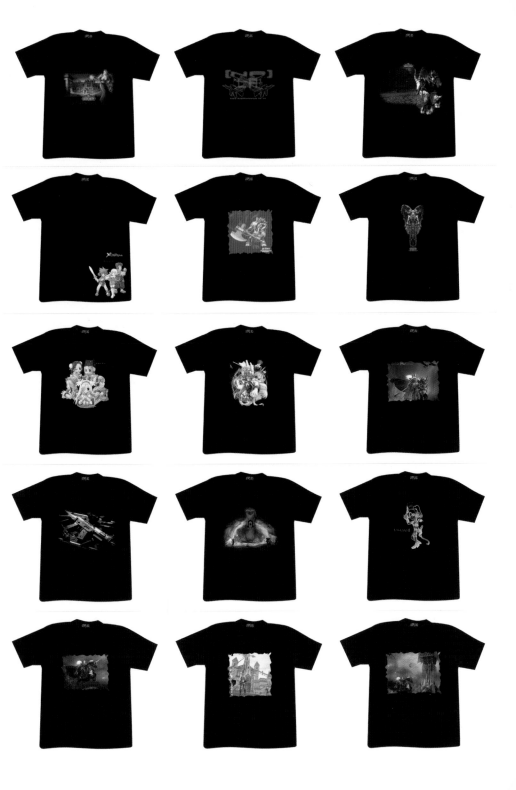

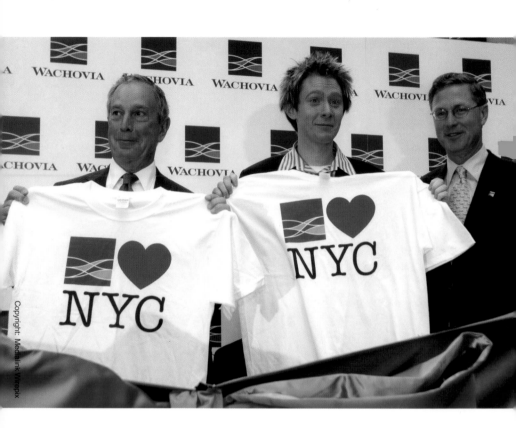

At the Eiffel Tower, the Kremlin, the Taj Mahal, or the Potala Palaca, T-shirts are the first souvenir tourists choose. Wearing a tourist T-shirt expresses the tourist's individual taste as well as goodwill towards the locale and local cutlure they are visiting. Besides, T-shirts make good gifts to bring back home. On the Great Wall of China, you can find T-shirts with such slogans as "One is not hero if he has not been to The Great Wall;" in New York, you can find T-shirts that say "I Love New York" or "God Bless America." From Amsterdam's Pilate, Egyptian Sphinx, and Thailand's elephant, T-shirts are *de rigeur* tourist uniforms.

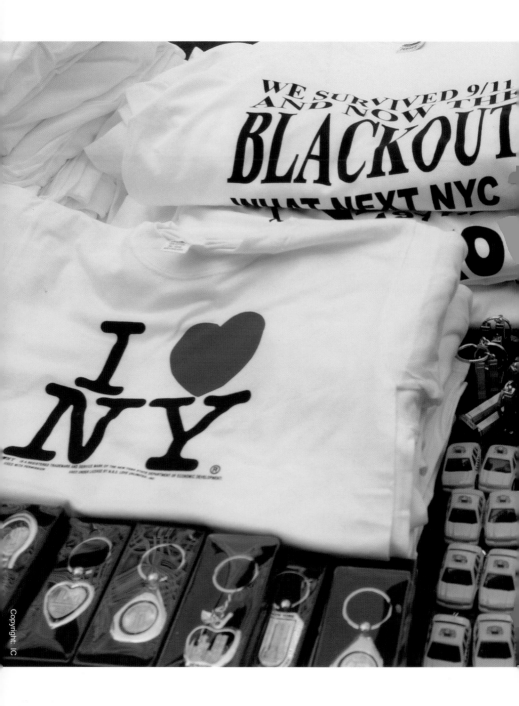

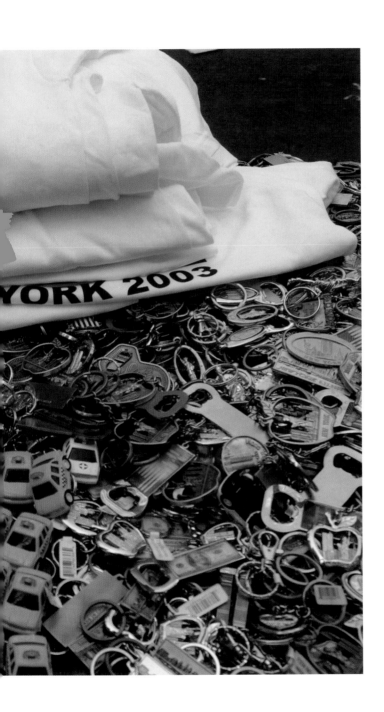

ATHENS

CHICAGO

CLEVELAND

MEXICO

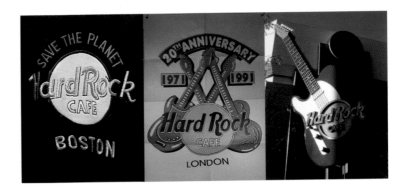

In 1971, Isaac Tigrett and Peter Morton founded the first Hard Rock Cafe in Hyde Park, London. Decades later, the Hard Rock Café has become a celebrity in its own right, and the Hard Rock T-shirt is an essential part of its popularity. Alan Aldridge, who designed the record jackets for the Beatles and Apple Records, designed the famous orange logo for Hard Rock. Hard Rock T-shirts have always been hot sellers with their distinctive sales appeal.

In such cities as New York, London, Jakarta, and Shanghai, Hard Rock Café T-shirts are printed with the name of the city. Ardent fans can travel around the world and collect the local version of the Hard Rock T-shirt restaurants from every city. T-shirt sales comprise an important part of Hard Rock's revenue.

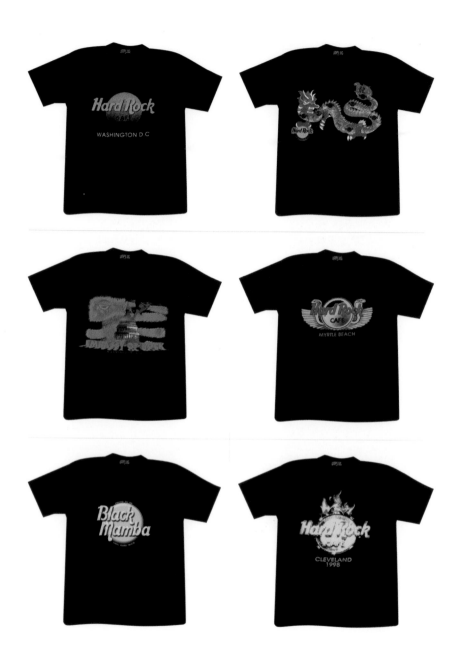

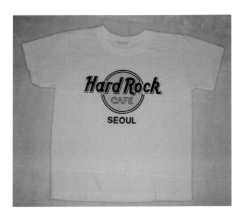

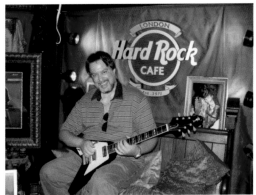

**213**
T-SHIRT

Logos and advertising seem to have become just as much a part of a soccer match as the players themselves. In the beginning, sportswear for the World Cup was blank, and it was only later that club logos were added. Today, it is full of brand names and logos with almost no space left.

Manchester United's team T-shirt is priced at £40 and it is the most requested Christmas gift of British children. In the early '80s, Adidas became an official team sponsor and introduced the famous three-stripe design to the club. Recently, Sharp's logo appeared in the front of the T-shirt, and in 2002, Nike became the main team sponsor with a thirteen-year contract worth $1 million (U.S.). Meanwhile, Chelsea signed a £50 million, five-year contract with Samsung, breaking the record of the annual sponsorship dollars. T-shirts with club logos, brand names, and player names have always been favorites of fans; everyone can feel as though he's part of the action.

**217**

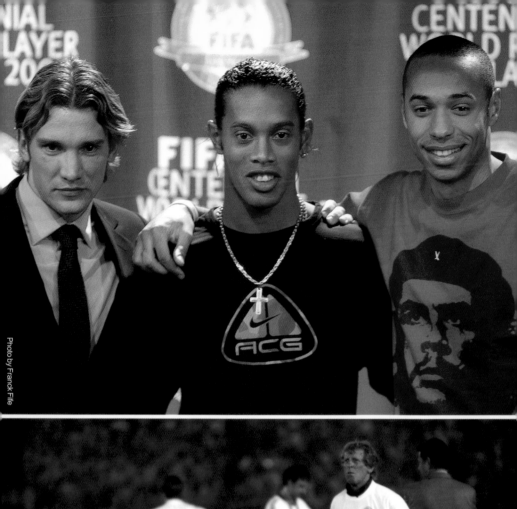

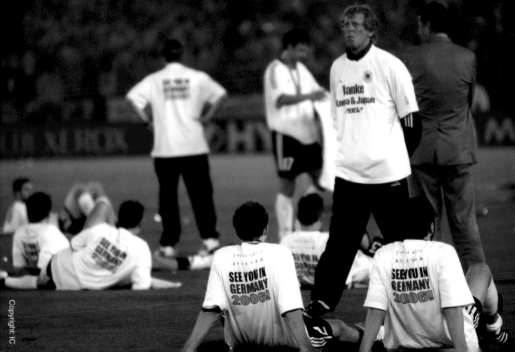

During the 2002 World Cup, the soccer players were dressed in a rich, stunning array of colors. The Umbro T-shirt of the English team was the first reversible jersey to be worn on the field. The French team's T-shirt had a three-color stripe on the shoulder that mimicked the French national flag. The Adidas T-shirt of the Japanese team had thin red stripes on each side, symbolizing Mount Fuji. The trim, lightweight, blue T-shirt of the Italian team was sponsored by Kapper. For all, the high-tech fabrics helped to keep the players cool in the hot and humid weather. Jerseys were sold at about ¥14,000 each.

The Barcelona team is the only one that does not allow any ads on their T-shirt except the brand and team's logo. The team thinks that no commercial advertisement is greater than the team's logo and it should be proud to promote big players like Kruif, Maradona, and Ronaldo. Meanwhile, the Barcelona club has the most registered members in the world, including the late Pope John Paul II and Juan Antonio Samaranch, former president of the International Olympic Committee.

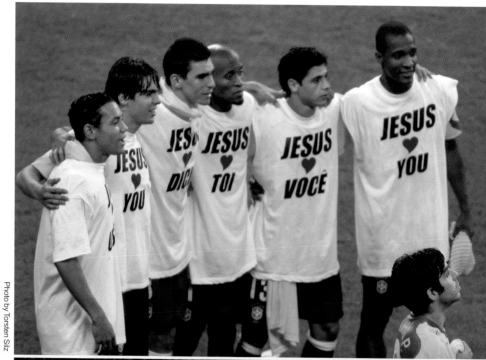

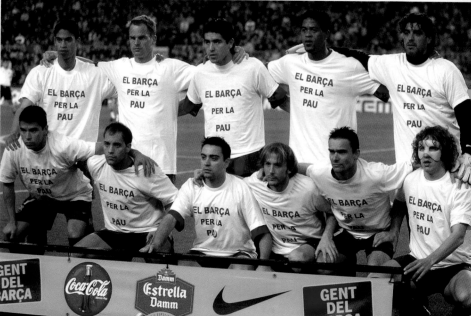

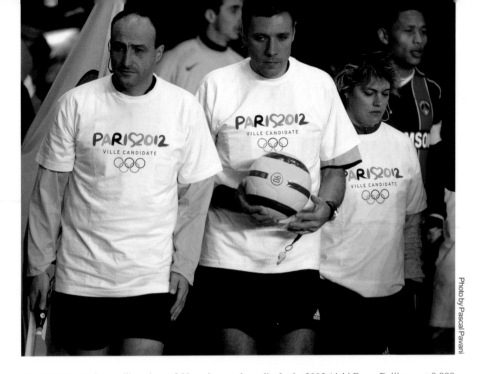

Photo by Pascal Pavani

The T-shirt is the best-selling piece of Olympic paraphernalia. In the 2005 Aichi Expo, Beijing sent 8,888 "Chinese Seal" T-shirts. In Athens 2004, Olympic souvenirs were three times more expensive than ordinary ones. A regular T-shirt would sell for 10 euros in Greece, but the price soared to 30 euros once printed with the Athens Olympics logo.

# Simple and Fashionable

6

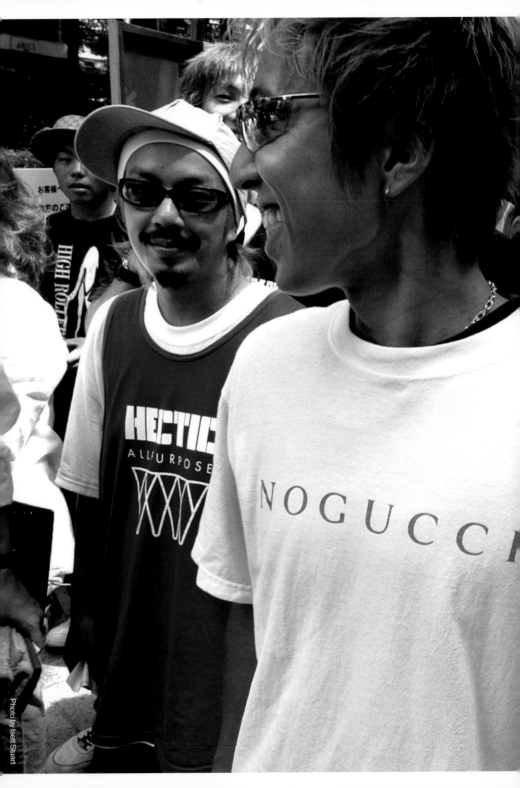

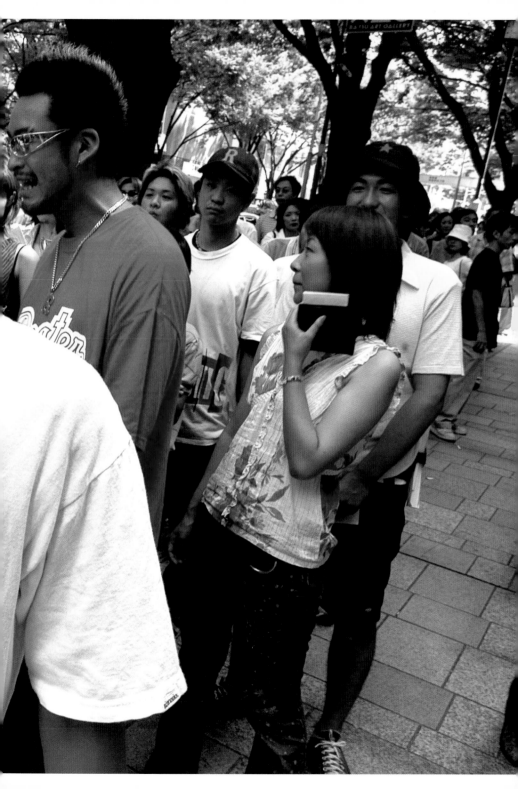

A simple T-shirt can cut a strikingly fashionable profile—from conservative (colored, striped T-shirts) to sexy (half-transparent T-shirts).

A pleated skirt paired with a T-shirt is a chic fashion choice for students. A summery knee-length skirt with a T-shirt creates a youthful and elegant look and is versatile enough to be worn to the office or on the street.

A stretchy T-shirt with short-shorts is the sure way to turn heads on carefree summer days.

A pair of mid-length trousers with a T-shirt and a pair of flats is a simple and casual combination.

A fitted T-shirt with a pair of low-rise trousers showcases the male physique. Extremely sexy, it poses strict requirements for the form and shape of the body and can be unforgiving to those who aren't in excellent physical shape.

A T-shirt with a pair of loose trousers is fashionable, appropriate for both men and women. With a round collar, in either a tight or loose fit, and when paired with a hooded top, the T-shirt is a fresh, energetic match for loose trousers.

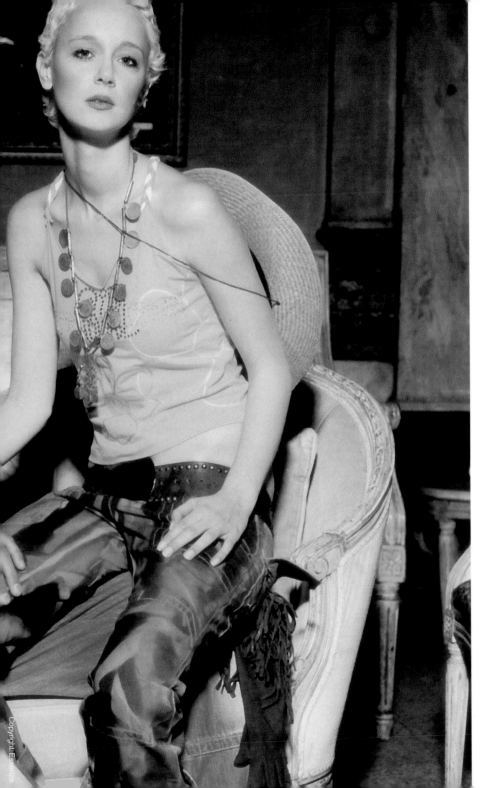

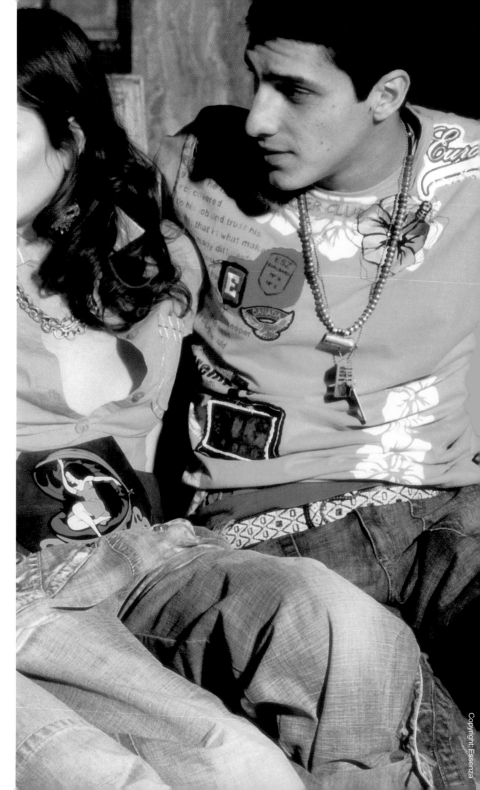

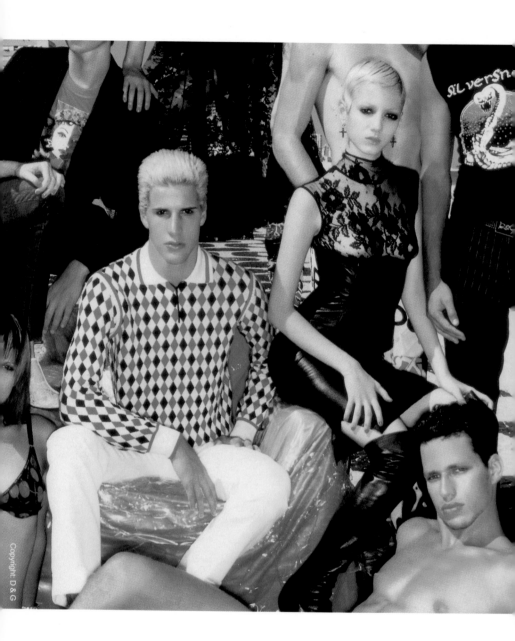

**234**
T-SHIRT

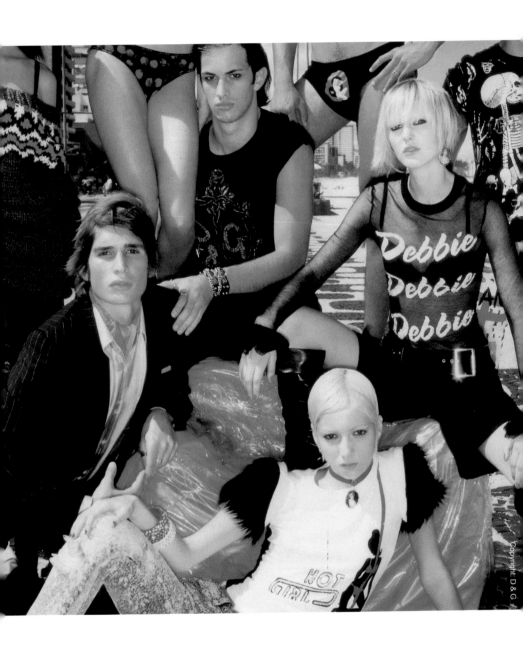

**235**
T-SHIRT

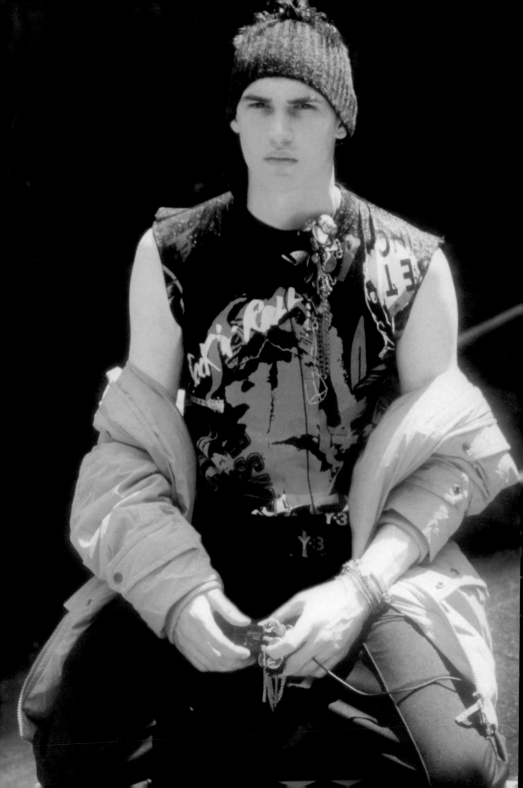

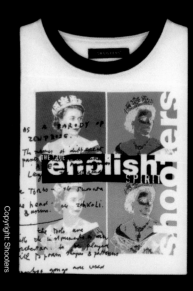

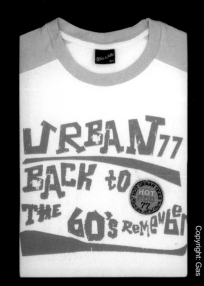

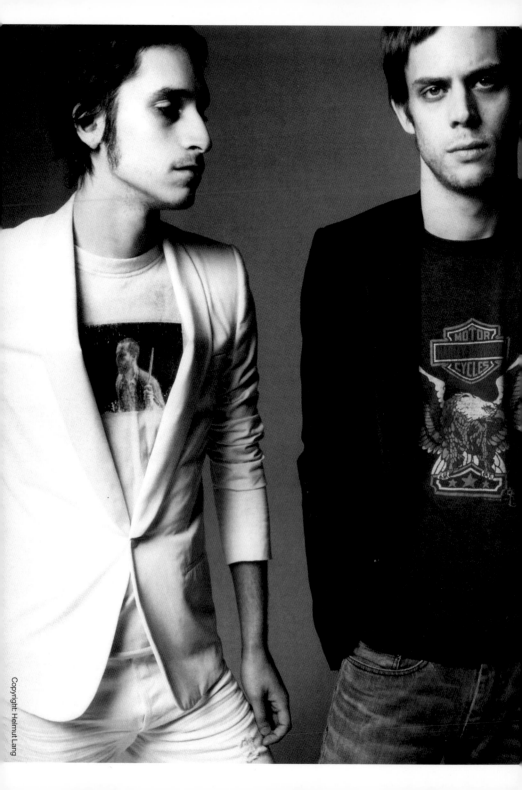

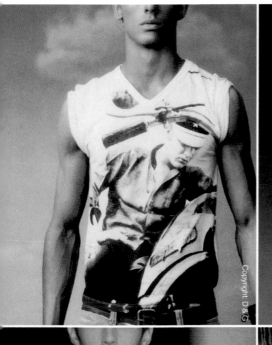

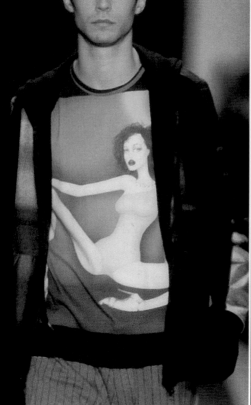

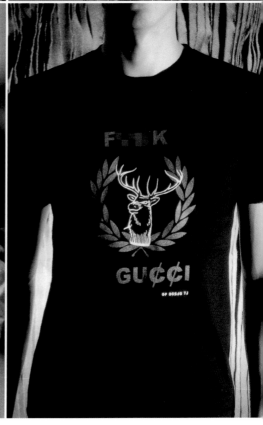

**240**
T-SHIRT

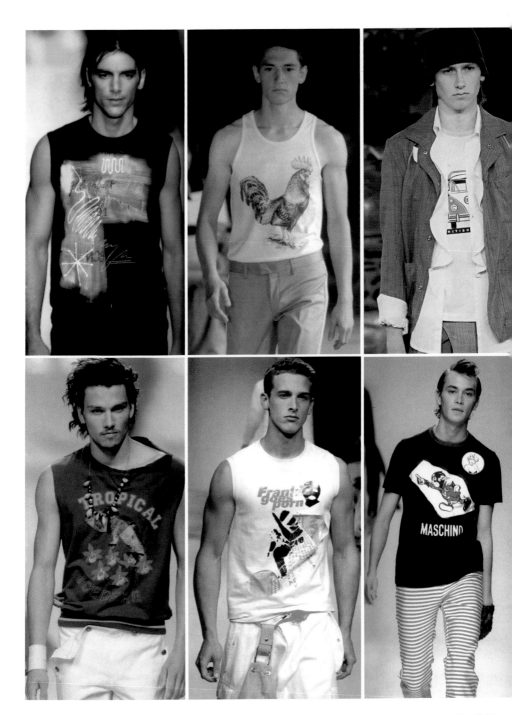

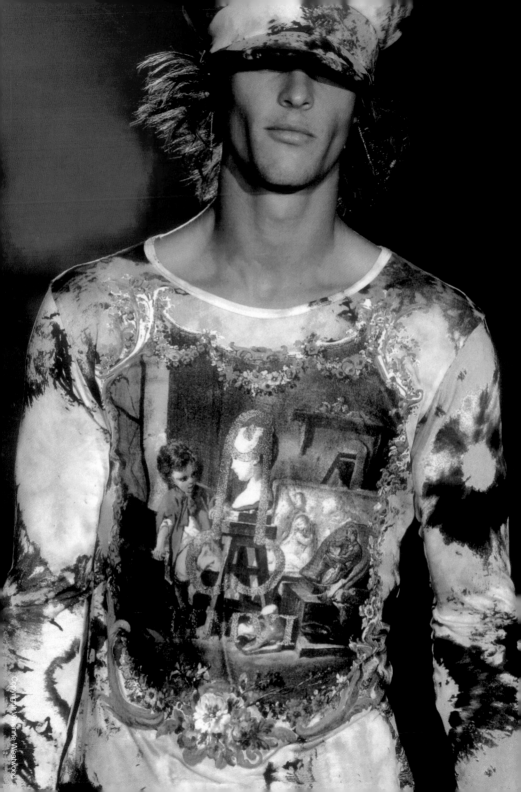

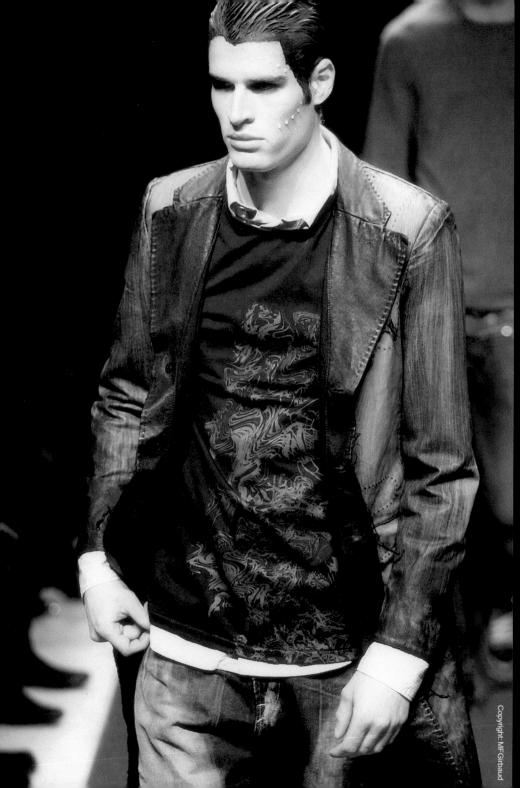

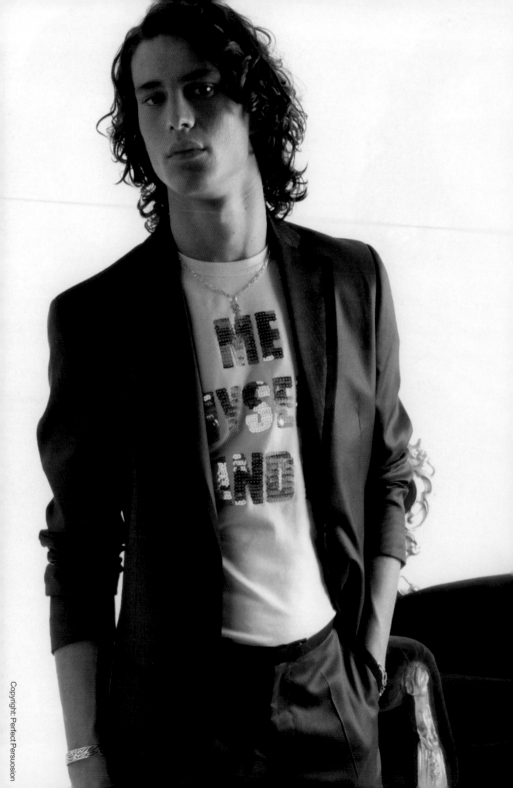

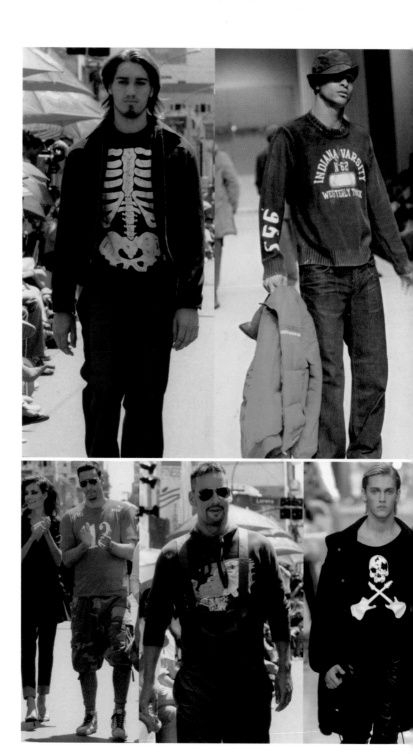

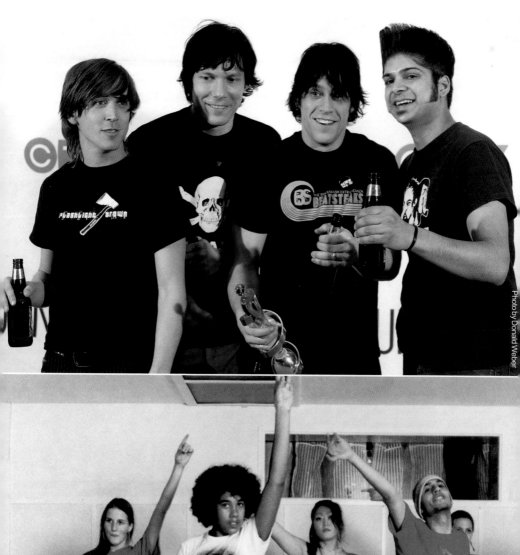

Photo by Donald Weber

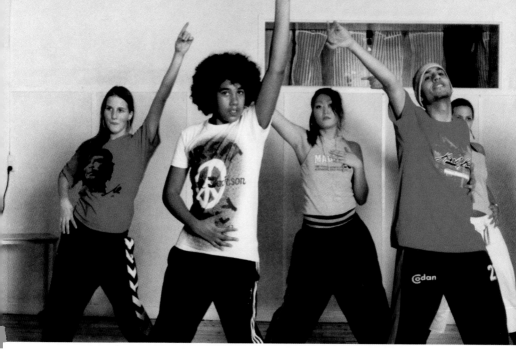

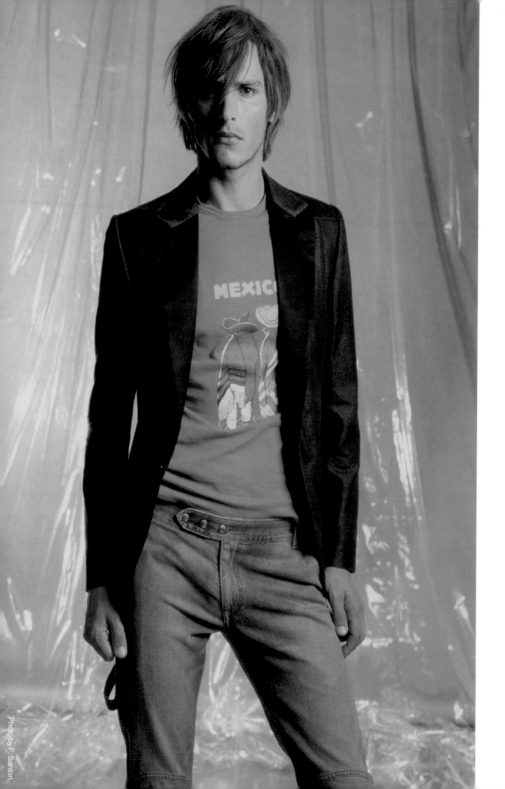

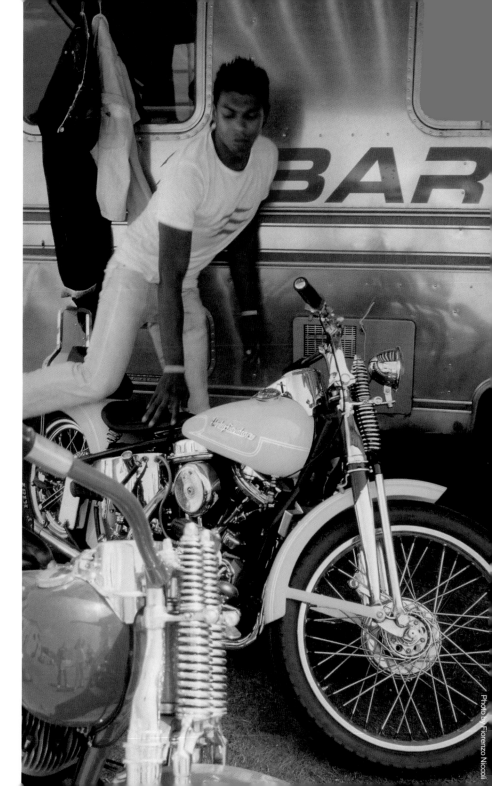

Photo by Peter Kramer

**253**
T-SHIRT

'I am really
happy with my
legs and my
hands and wrists,
which remind me
of my mom'

Developed from underwear, the T-shirt was meant to be sexy. A plunging neckline and a wet T-shirt is thought to drive any man wild, and a super-long T-shirt worn as a mini-dress leaves just enough to the imagination.

ゴールウインド・トート

**257**
T-SHIRT

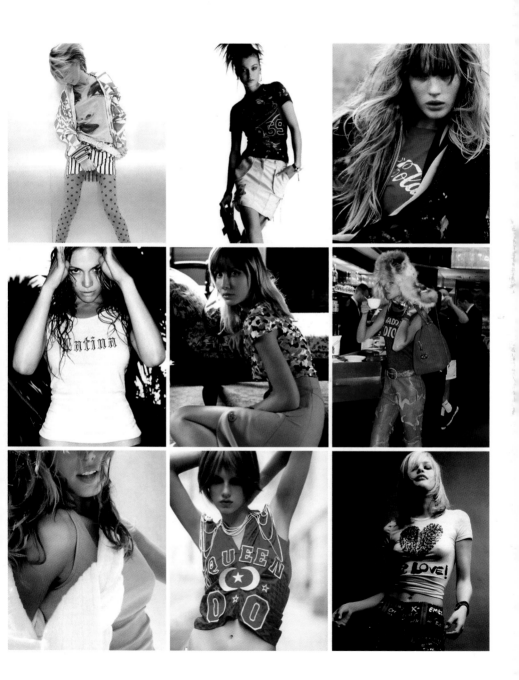

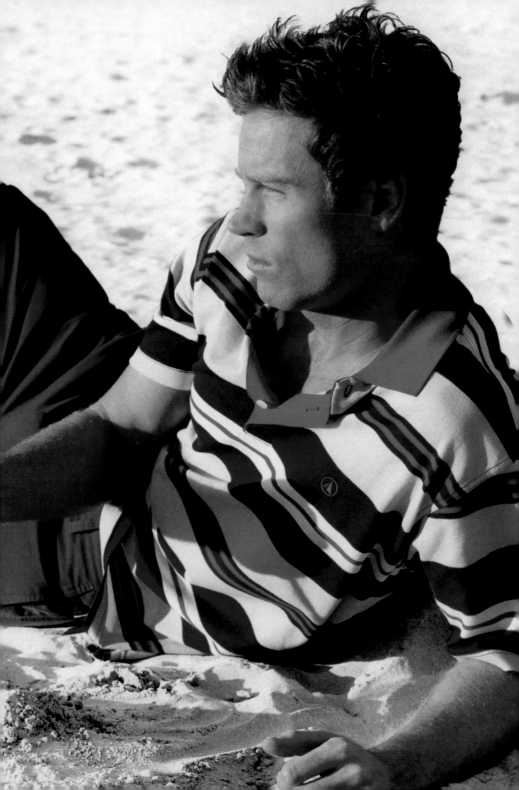

Contrary to popular belief, the polo shirt was not developed by Ralph Lauren. First manufactured by Lacoste, polo T-shirts are button-down, collared T-shirts. These shirts were inspired by the shirts typically worn by polo players. To make sure that collars would not inhibit the players, buttons were used. And buttons in front made the shirts easy to put on. Students from Ivy League universities often wore polo T-shirts, increasing their popularity, and adding to their exclusive appeal.

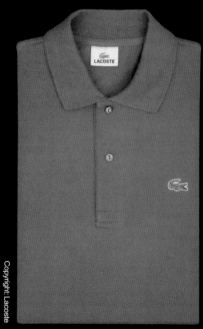

**263**
T-SHIRT

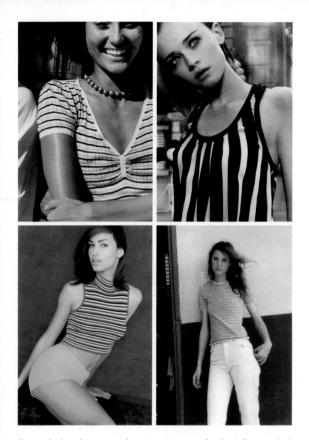

Strong design elements, stripes are never out of style. A few magical
stripes can create a perfect shirt. In the eighteenth century, the striped
T-shirt was the uniform of the French Navy. Black-striped tops
designed by Chanel are both delicate and youthful.

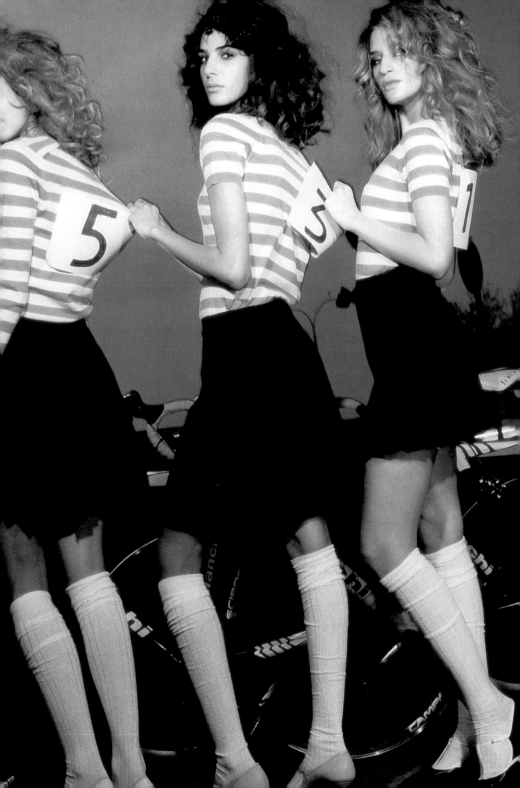

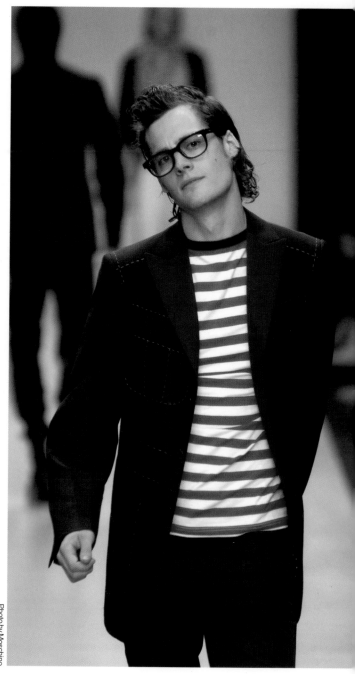

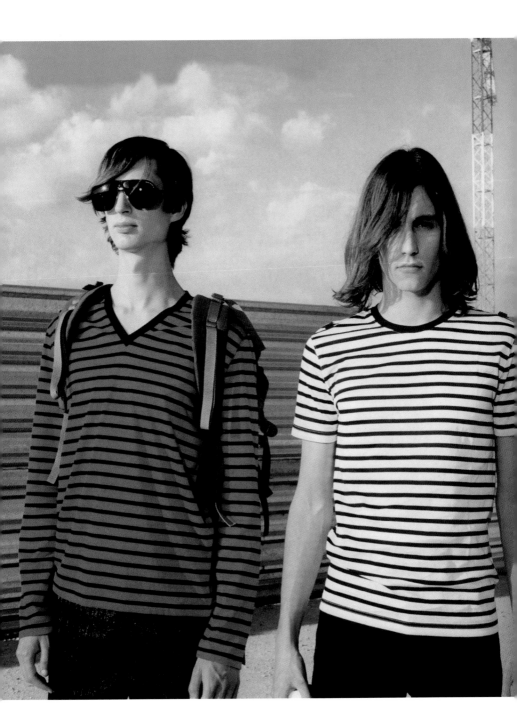

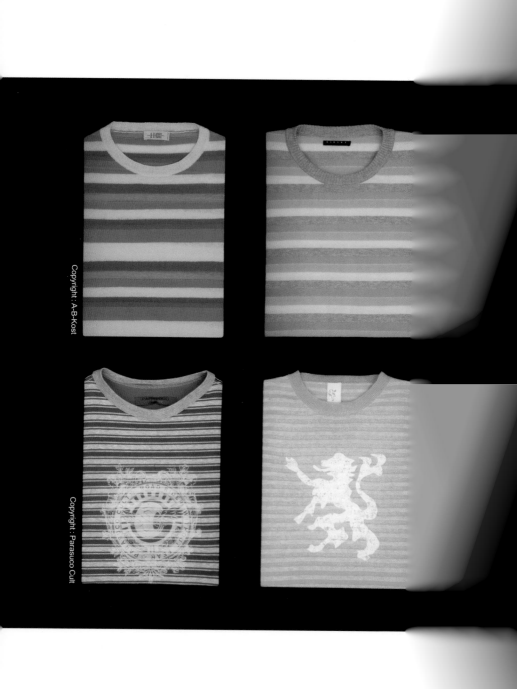

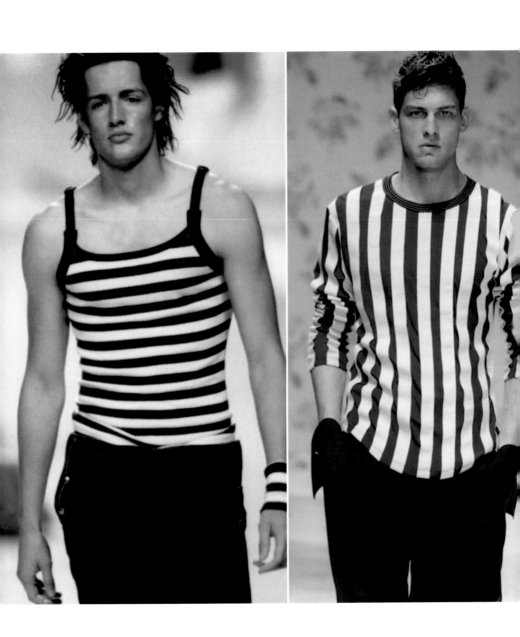

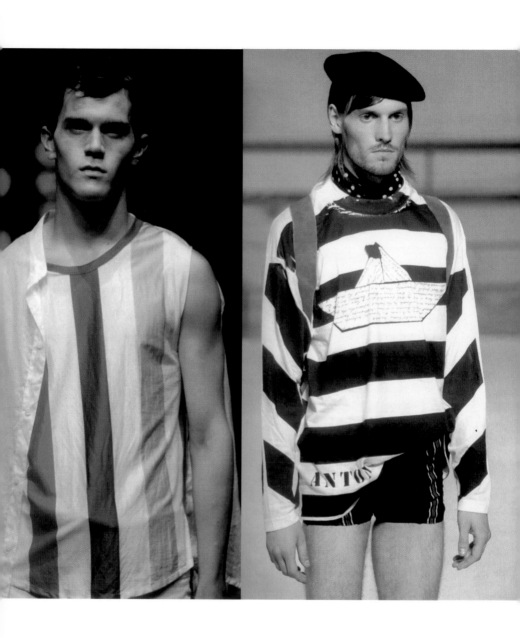

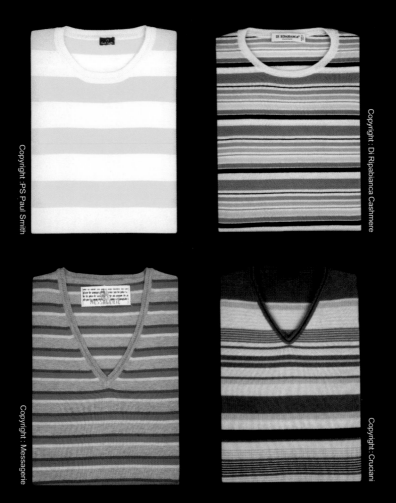

**271**
T-SHIRT

Despite many variations, the most classic style is the basic cotton T-shirt. After 100 years, this basic style is still undoubtedly the leader. The focus of design lies in the front; in this case, the T-shirt design becomes a print advertisement.

Round collars, V-collars, and square collars are the main collar styles on T-shirts. Some use different colors on the collars. Designers are always creatively altering prints on the front while deliberately breaking collars and cuffs, or using chemicals to oxidize the shirt's surface, replicating the look of torn jeans.

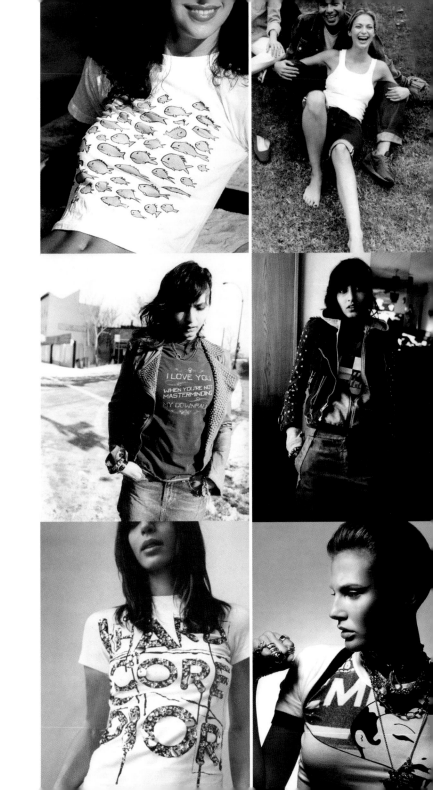

**274**
T-SHIRT

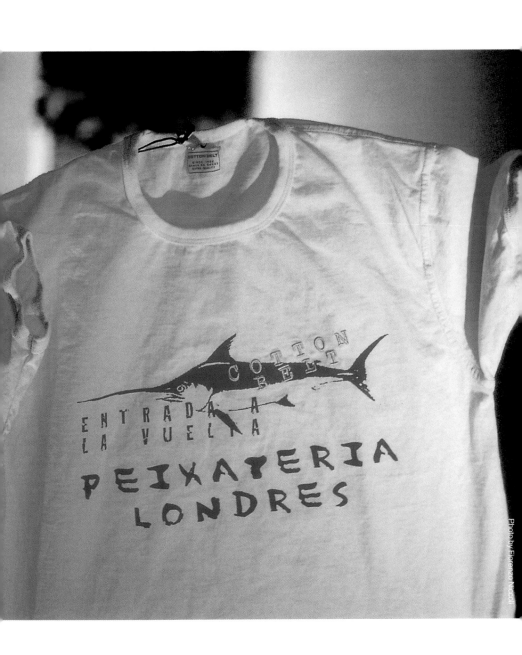

Photo by Fiorenzo Niccoli

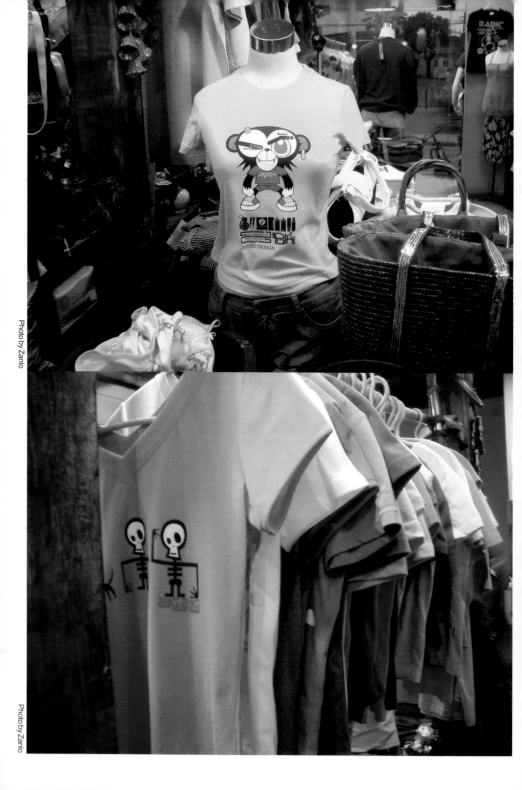

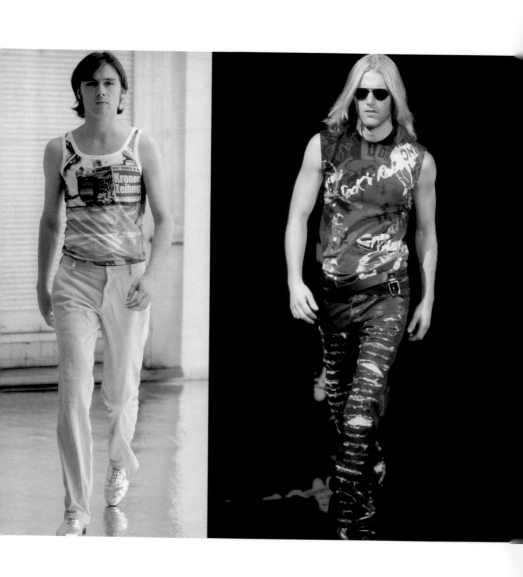

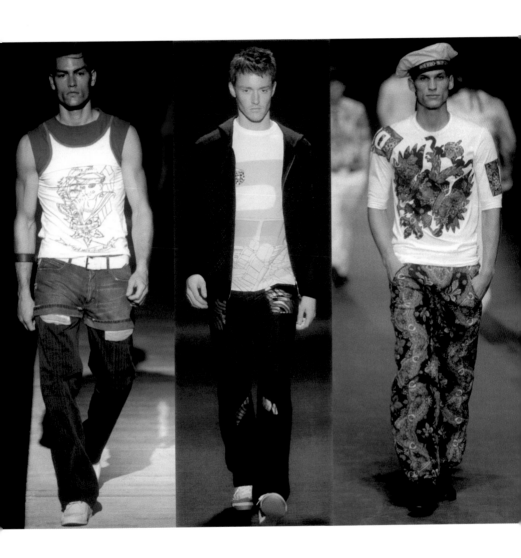

**279**
T-SHIRT

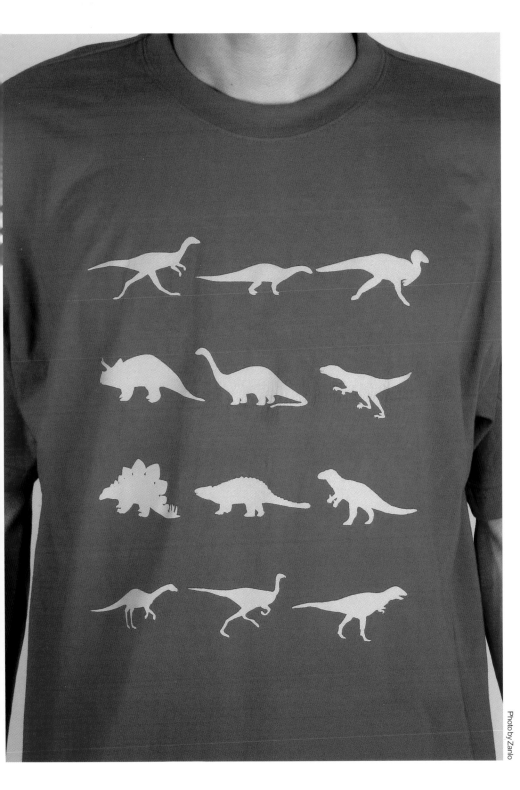

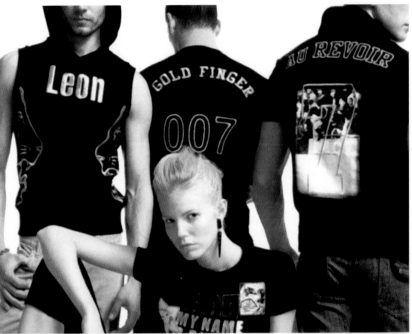

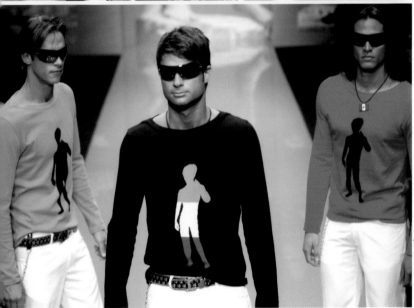

**282**
T-SHIRT

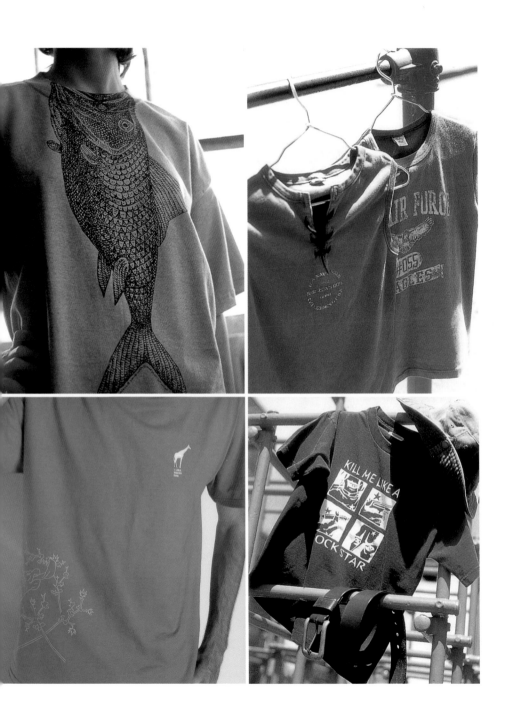

**284**
T-SHIRT

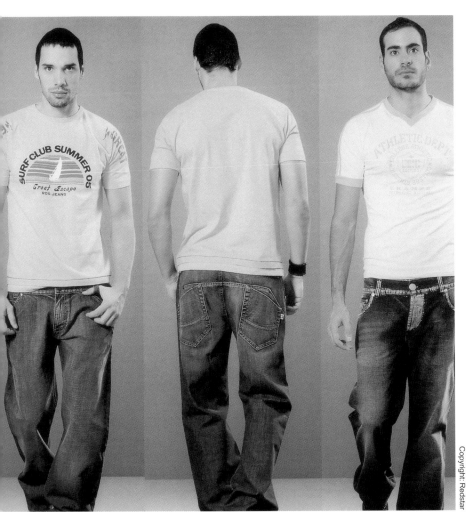

**285**
T-SHIRT

**286**
T-SHIRT

**287**
T-SHIRT

**288**
T-SHIRT

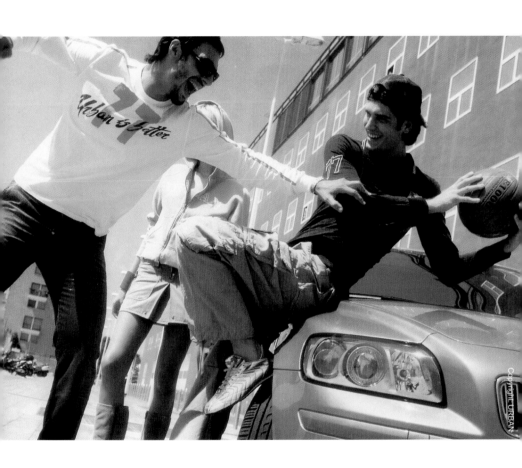

**289**
T-SHIRT

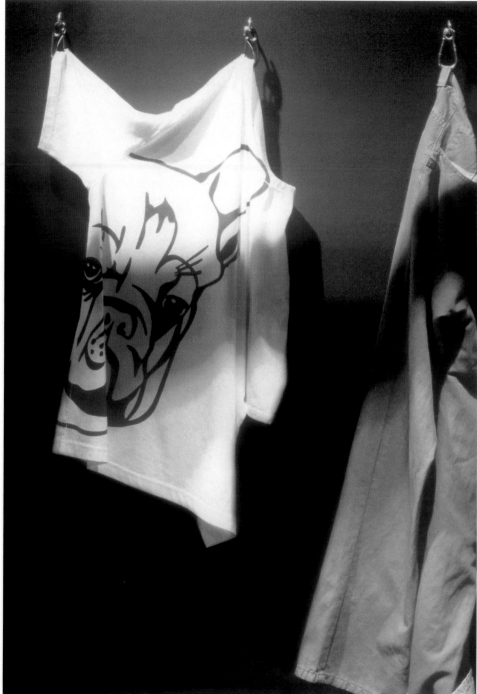

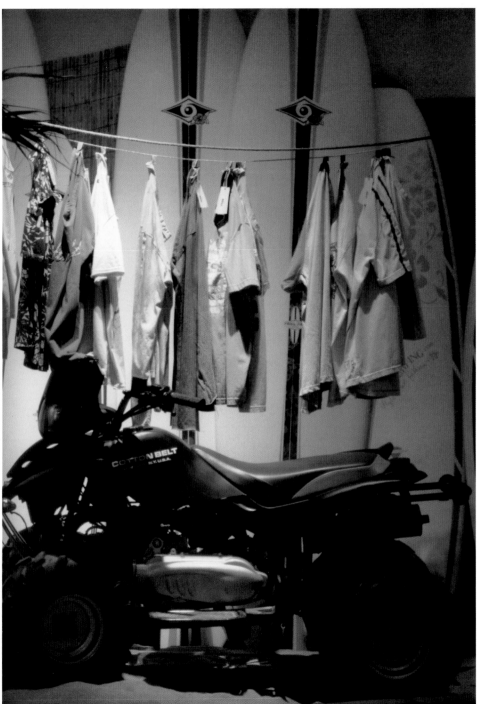

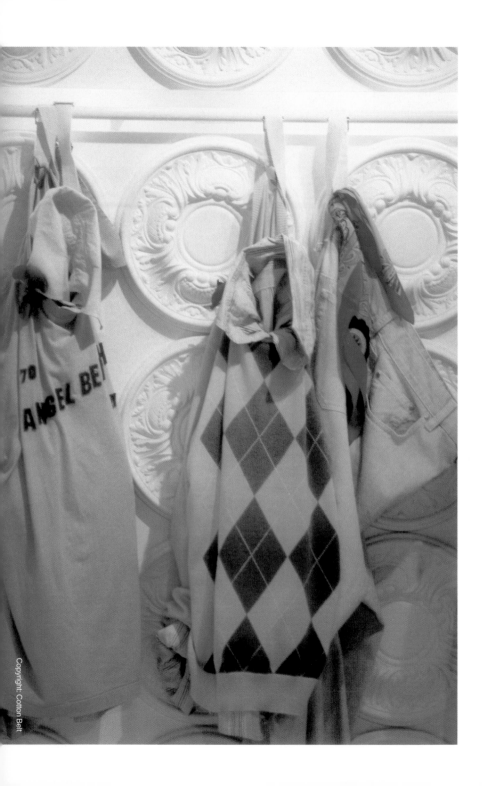

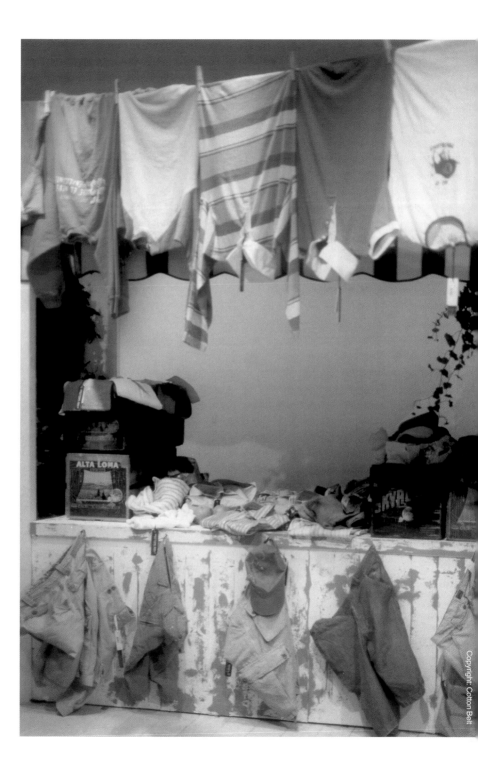

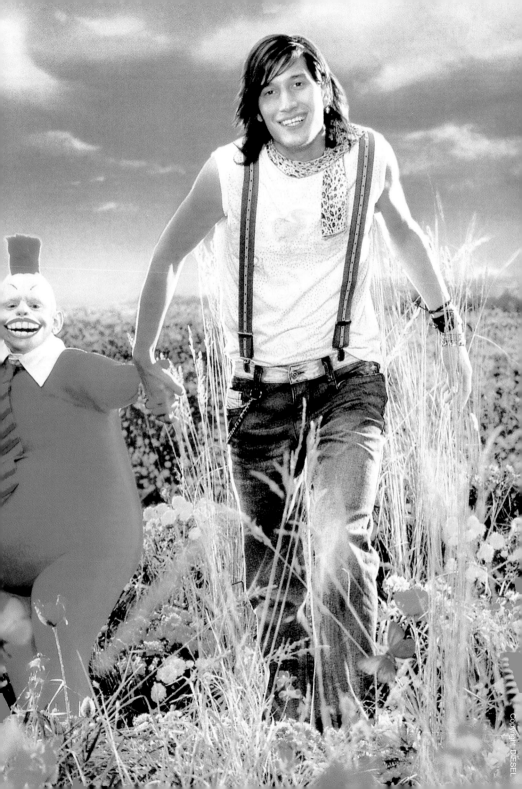

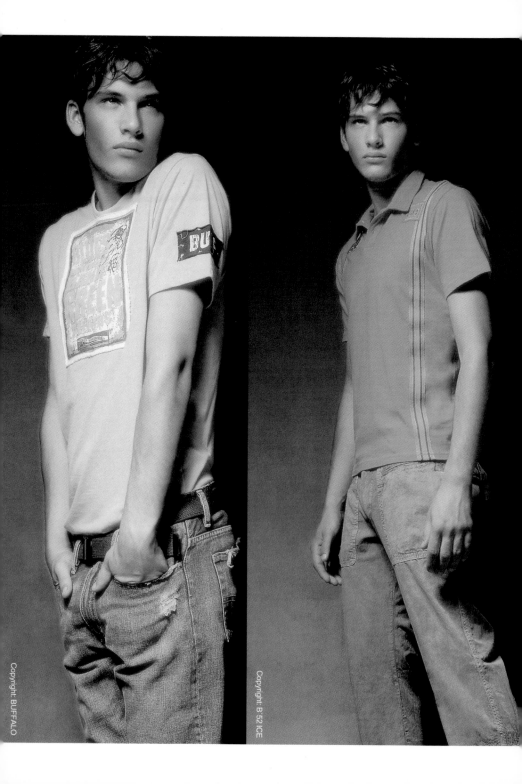

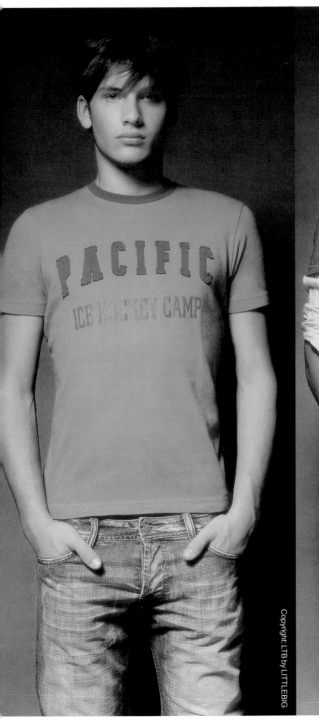

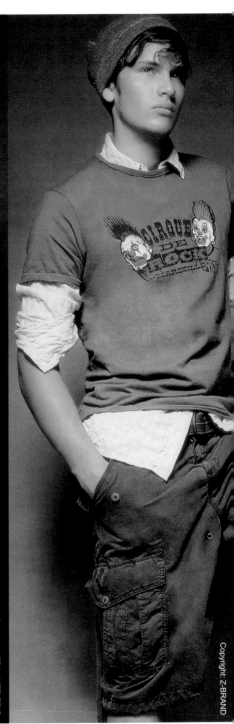

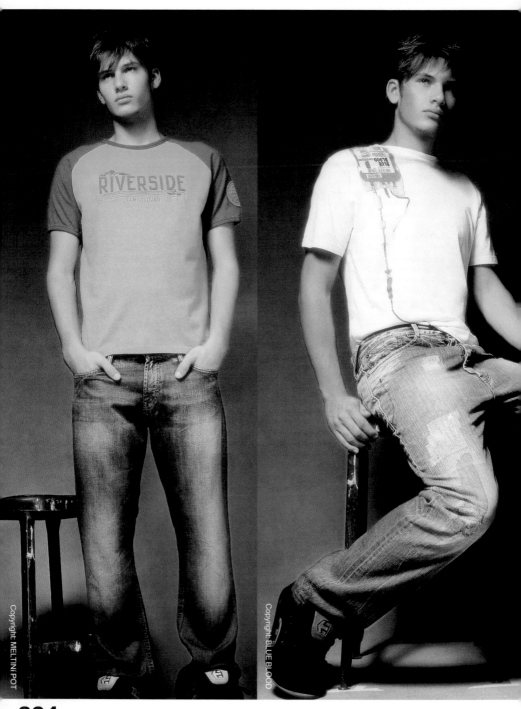

Copyright: MELTINI POT

Copyright: BLUE BLOOD

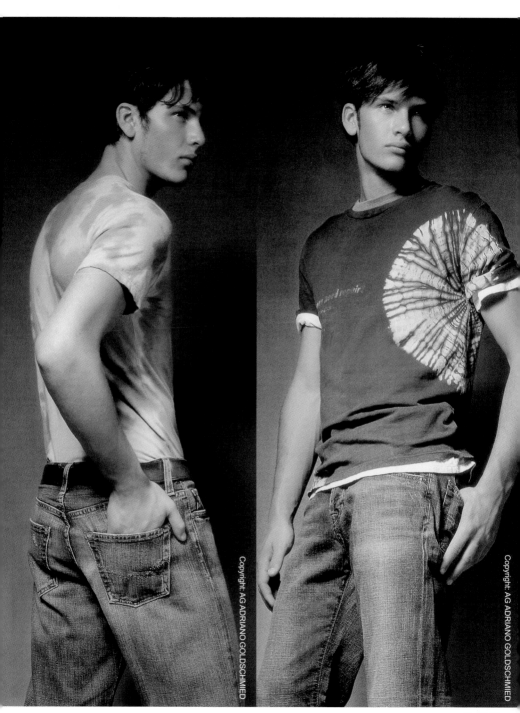

**305**
T-SHIRT

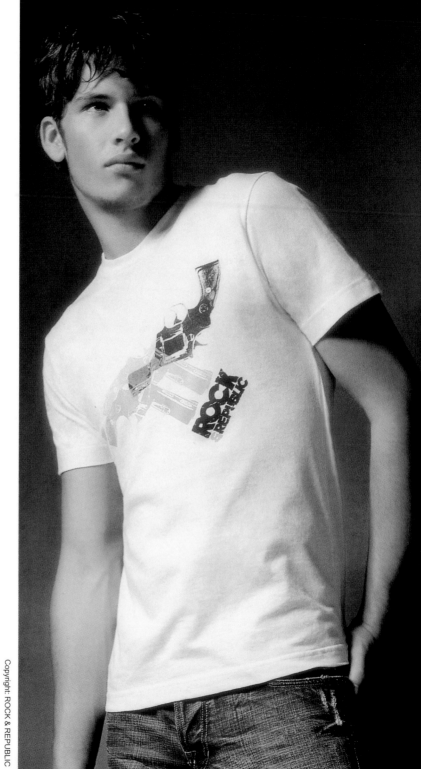

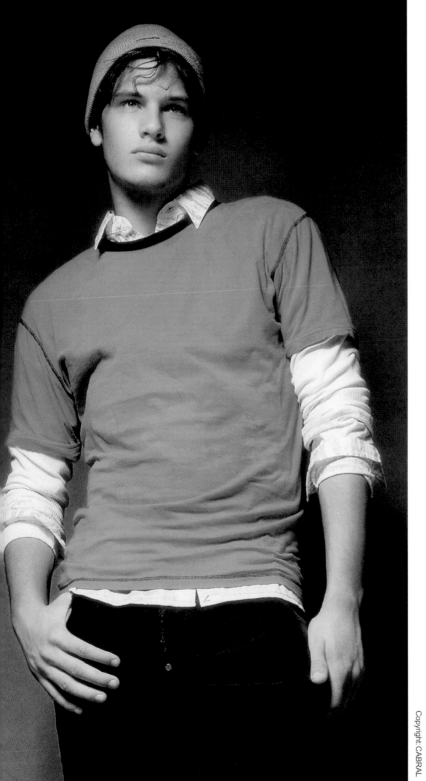

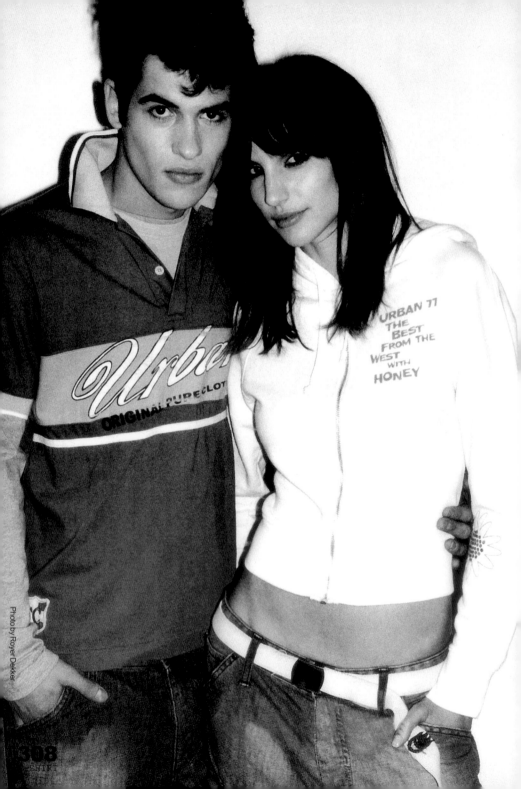

URBAN 77
THE
BEST
FROM THE
WEST
WITH
HONEY

Photo by Royer Dekker

308

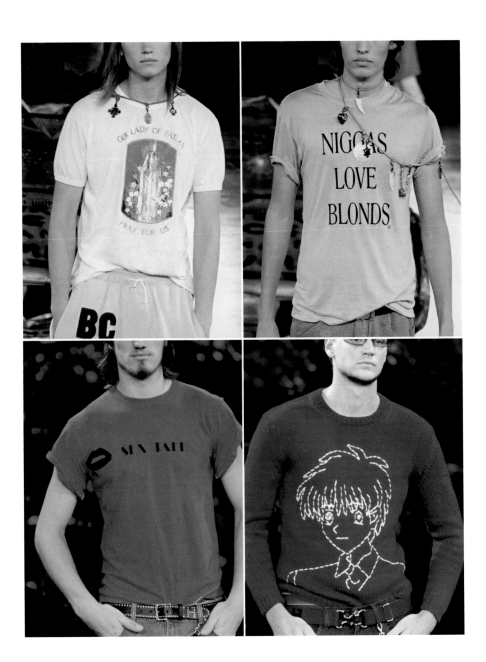

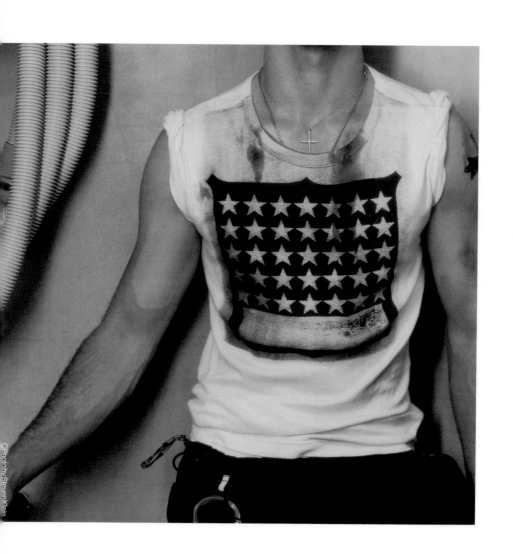

©Photo by Steven Klein

**310**
T-SHIRT

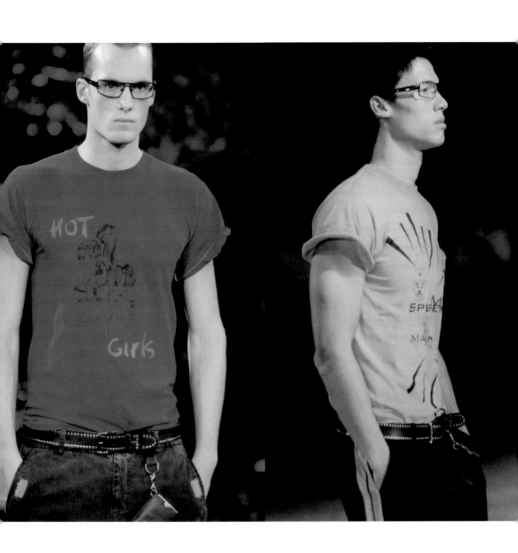

**311**

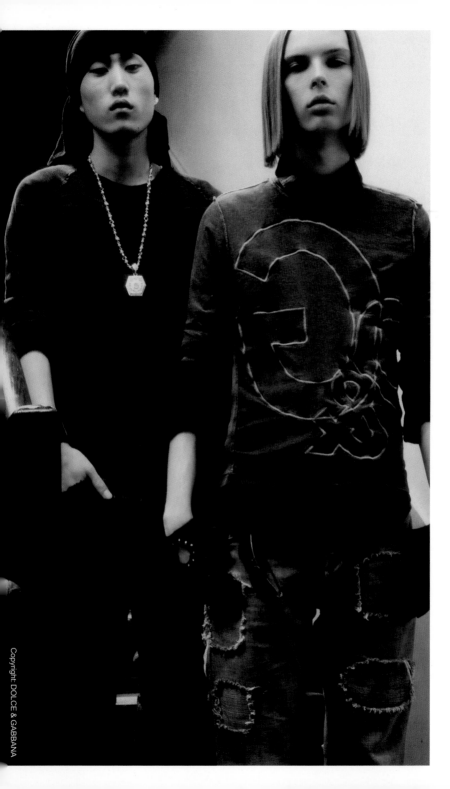

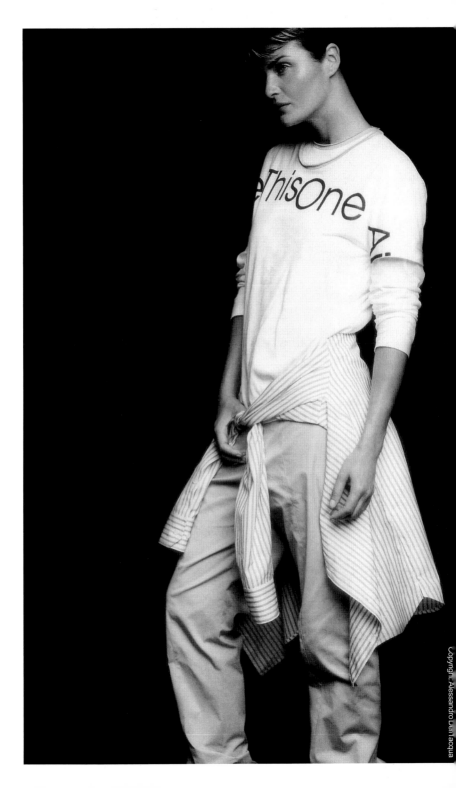

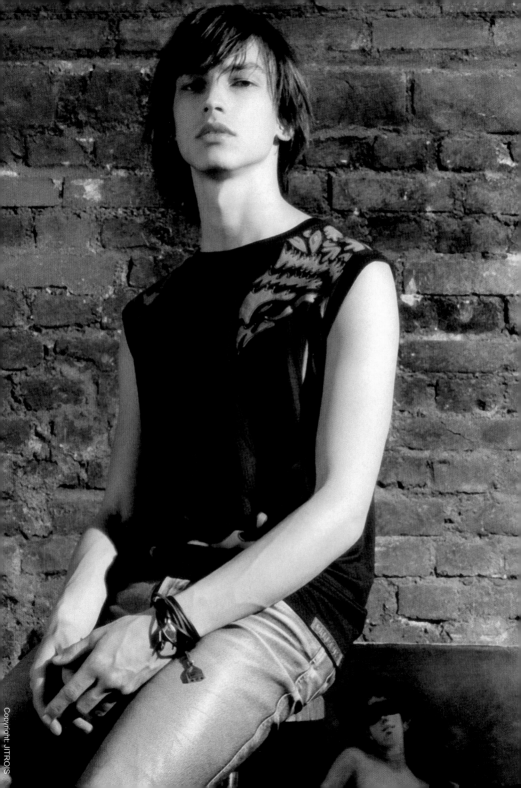

**315**

**316**
T-SHIRT

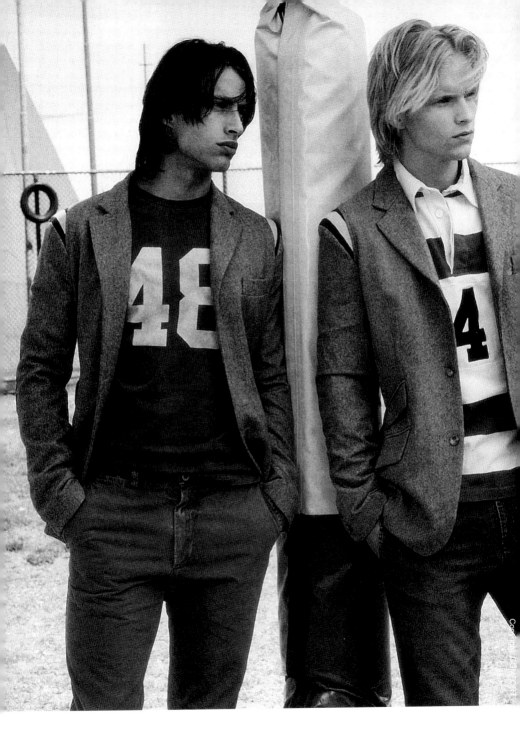

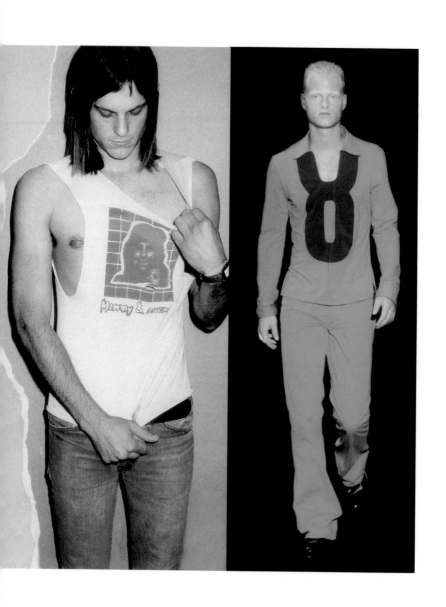

**318**
T-SHIRT

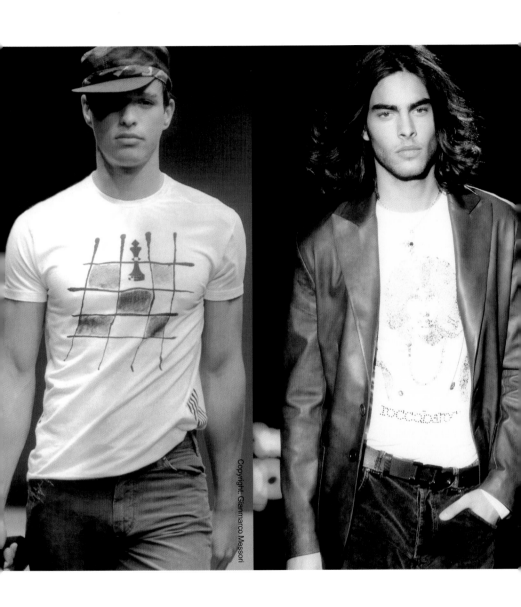

Copyright: Gianmarco Messori

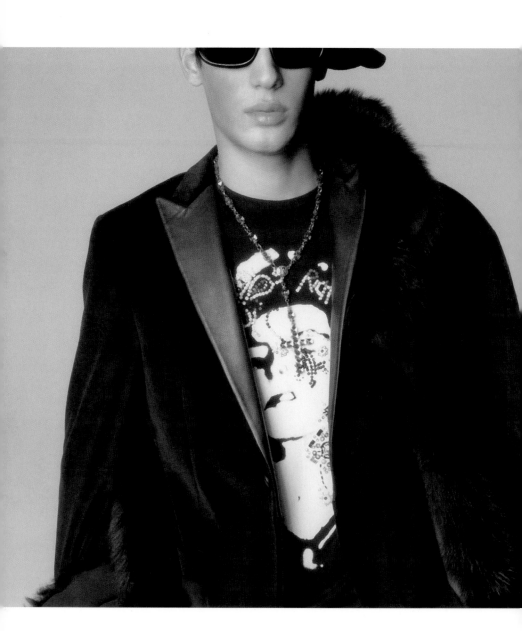

**320**
T-SHIRT

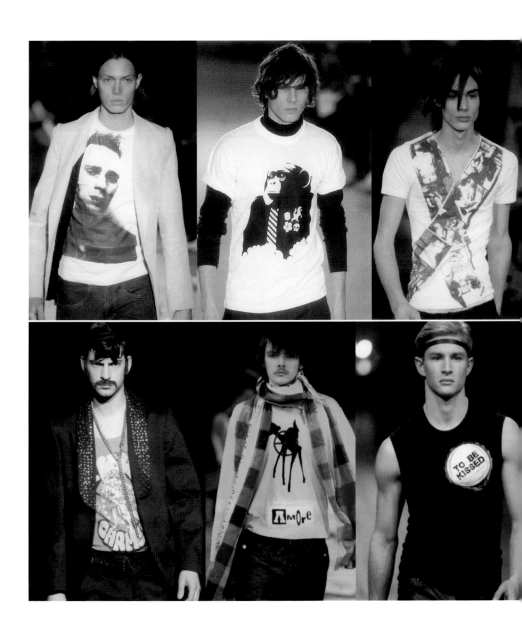

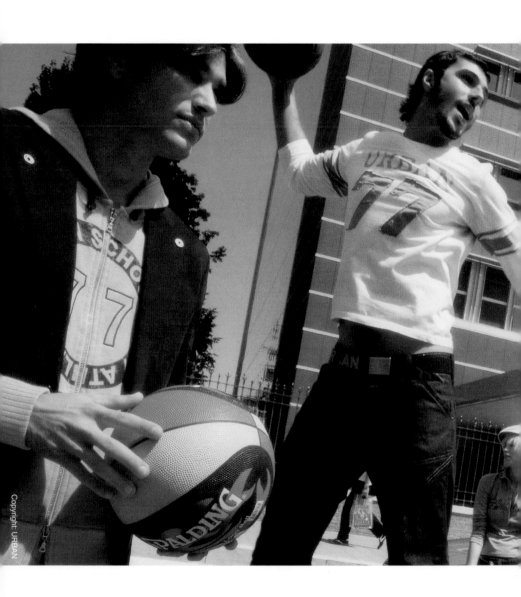

**322**
T-SHIRT

**323**
T-SHIRT

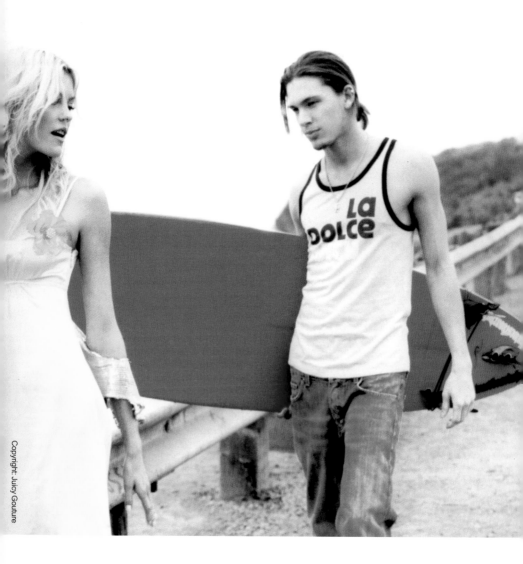

**324**
T-SHIRT

Tank tops are sleeveless T-shirts. These tops impart toughness in just about anyone who wears them. Typically tight fitting, these shirts show off a toned body and their lack of sleeves show off tattooed arms and muscular biceps.

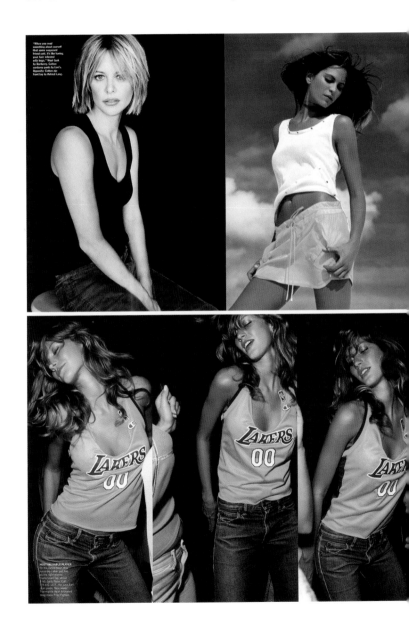

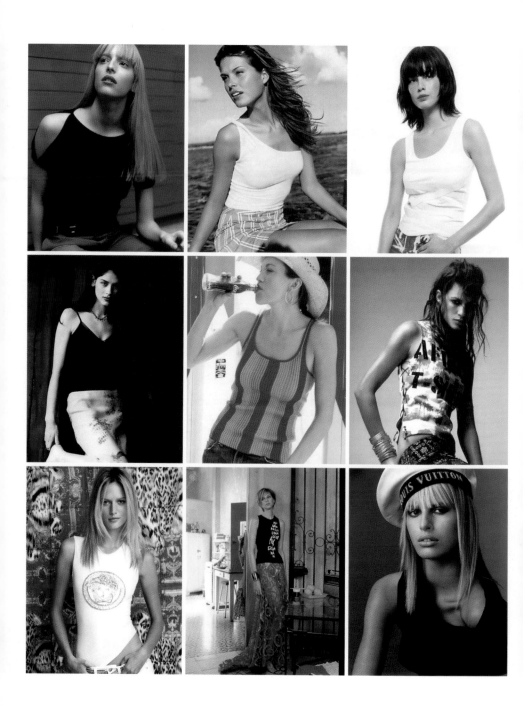

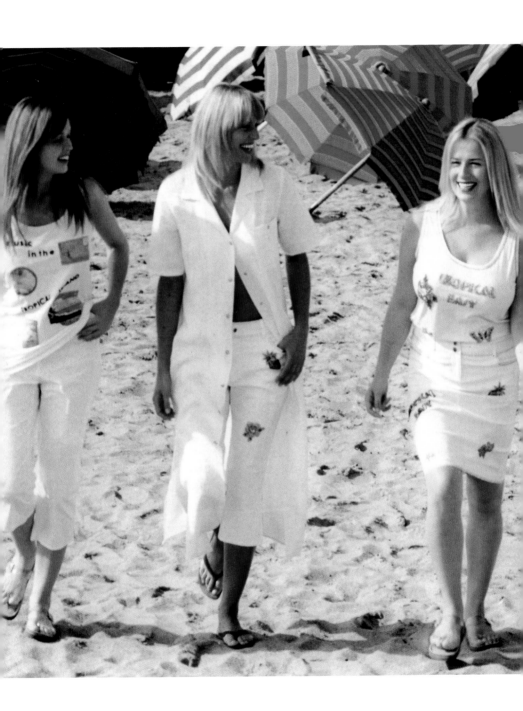

# Design Element 7

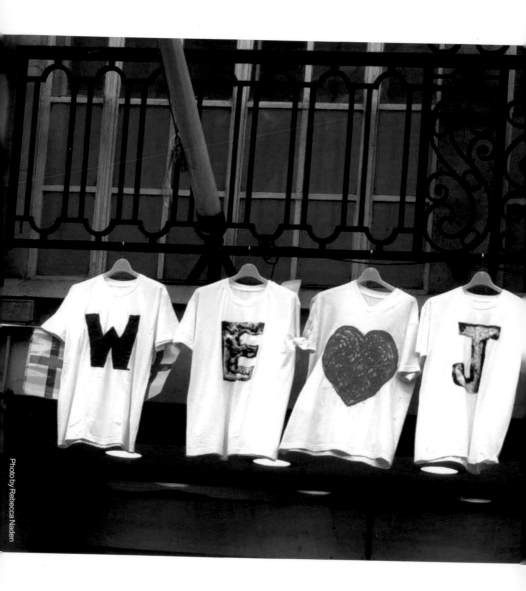

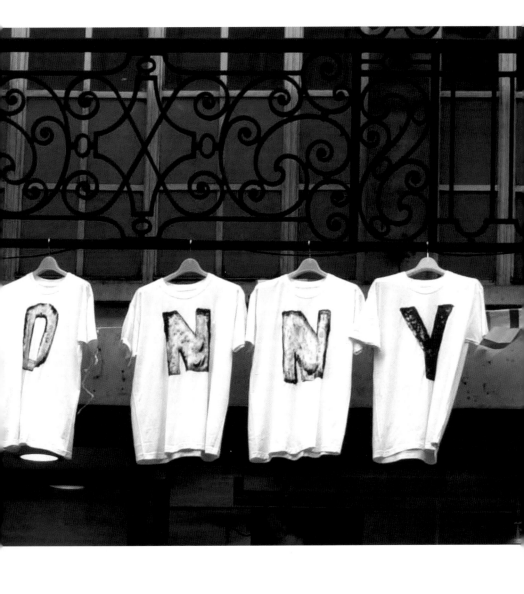

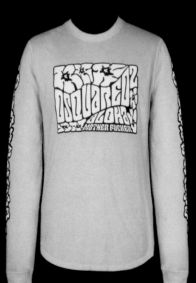

INTRRR
ODUCT
IOИ

Editor/Designer: RUDY VANDERLANS. Editorial consultant: ALICE POLESKY. Distribution, promotion and editorial assistance: ELIZABETH DUNN. Typeface design (this issue): BARRY DECK. Technical support: GERRY VILLAREAL. Emigre is published four times a year by Emigre Graphics. Copyright © 1991 Emigre Graphics. All rights reserved. No part of this publication may be reproduced without written permission from the contributors or Emigre Graphics. Emigre magazine is a trademark of Emigre Graphics. ISSN 1045-3717.

Send all correspondence to: Emigre, 48 Shattuck Square, №175, Berkeley, CA 94704 USA. ... 9021. Fax (415) 644 0820. Phone ... PLEASE SEND ADDRESS POSTMASTER ... CHANGES ... SHATTUCK SQUARE, №175, ... BERKELEY, CA 94704 - 1140, USA. ... TION 6,500. SUBSCRIPTIONS: $28 (four issues)

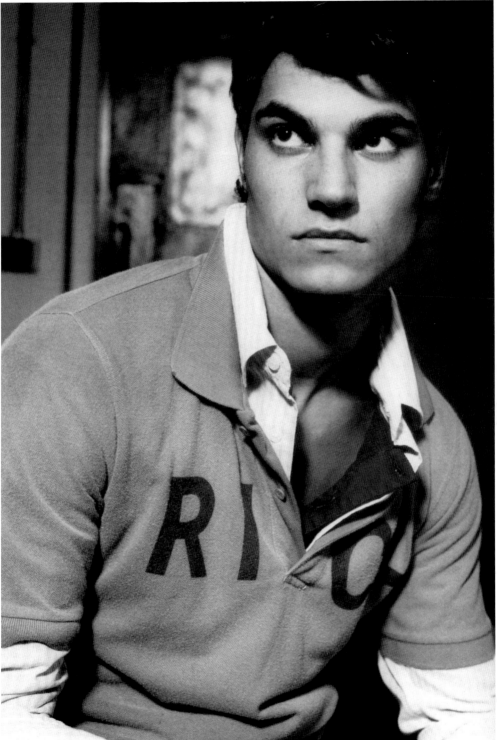

"I STILL RIDE IN THE SNOW
I STILL RIDE WHEN IT'S 30 DEGREES
BELOW ZERO"

Mark Sullivan
Mt K2 Jan.2084

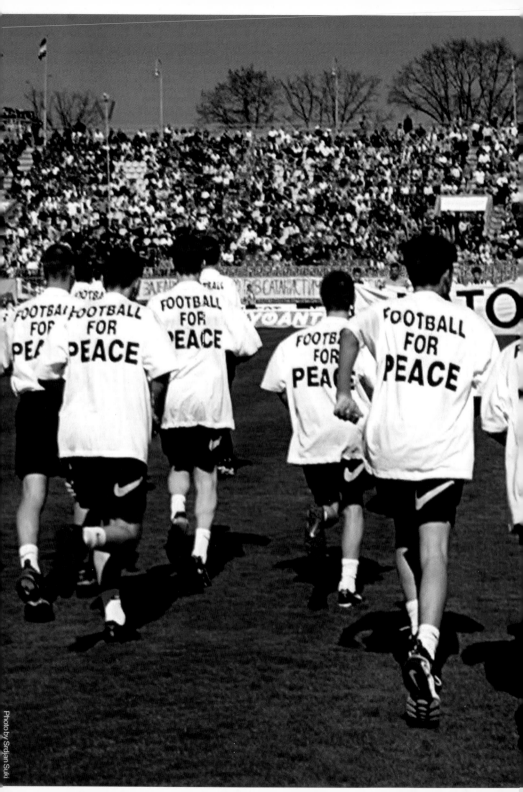

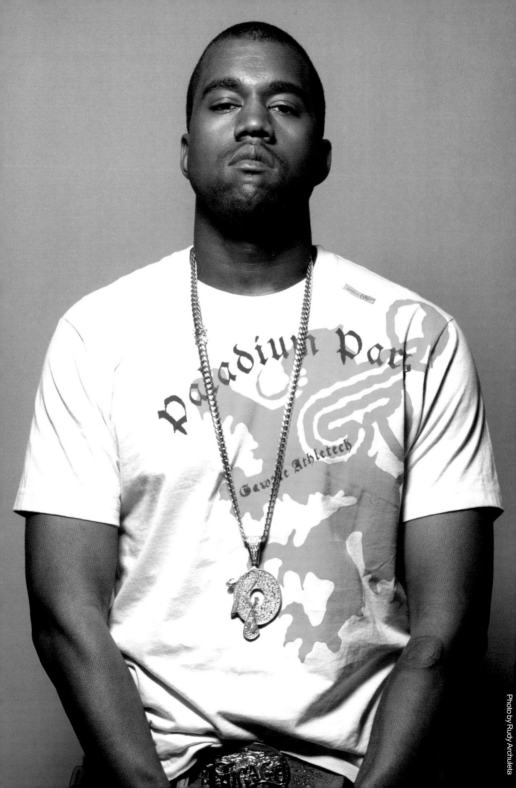

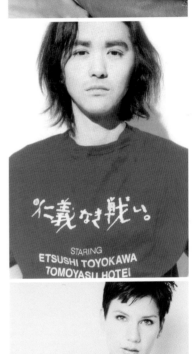

仁義なき戦い。

STARING
ETSUSHI TOYOKAWA
TOMOYASU HOTEI

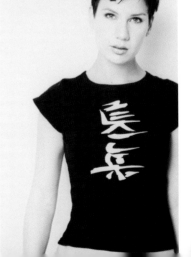

Photo by Jonathan Frantini

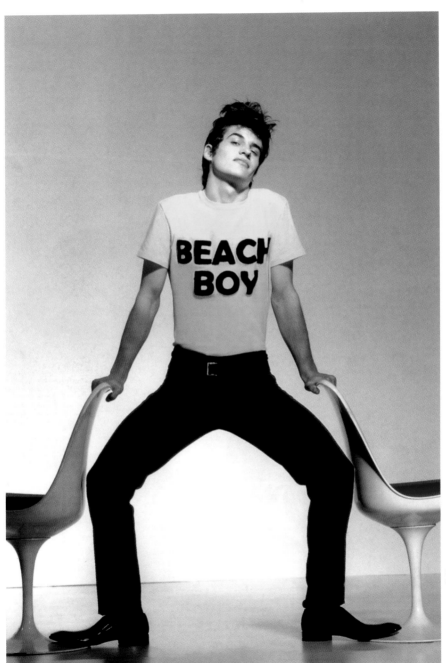

**351**
T-SHIRT

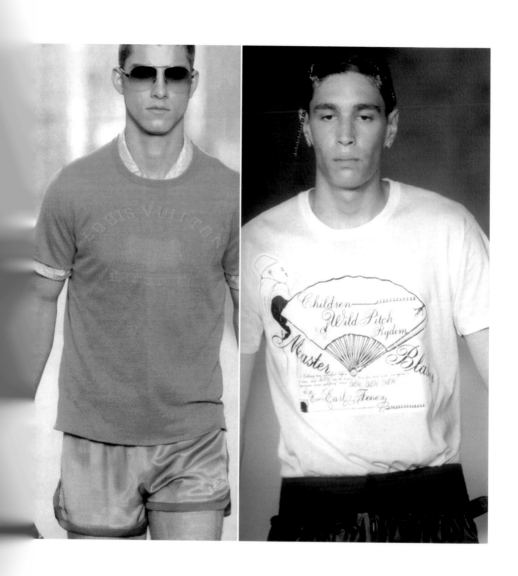

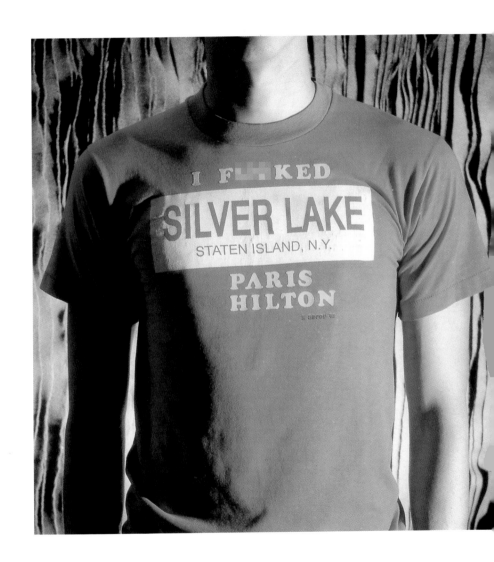

## Cartoon Elements

Following the cartoon boom, cartoon T-shirts have gained popularity. Hello Kitty, Xiaoxin, Saint-seya from Japan, and Spiderman and Superman are popular elements in T-shirt design. For a new cartoon, a T-shirt is the best promotional tool. Cartoon characters are popular for all ages, which is why Mickey Mouse, in all of his incarnations, has been an ever-present image on T-shirts for decades.

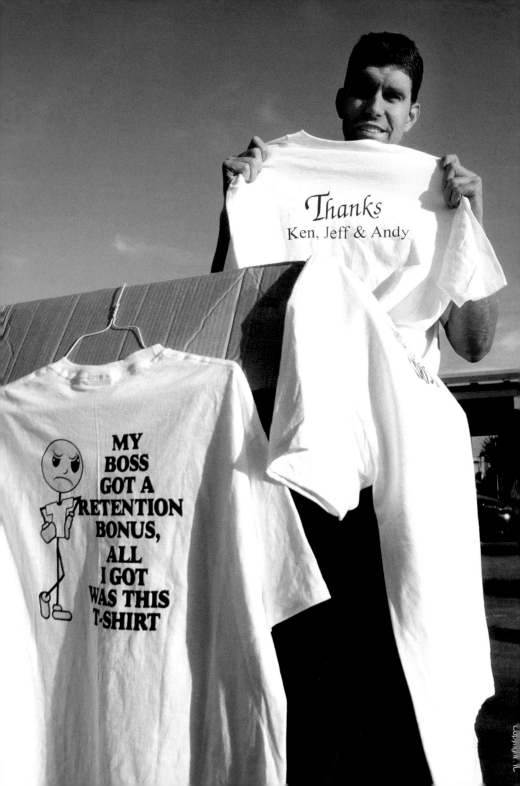

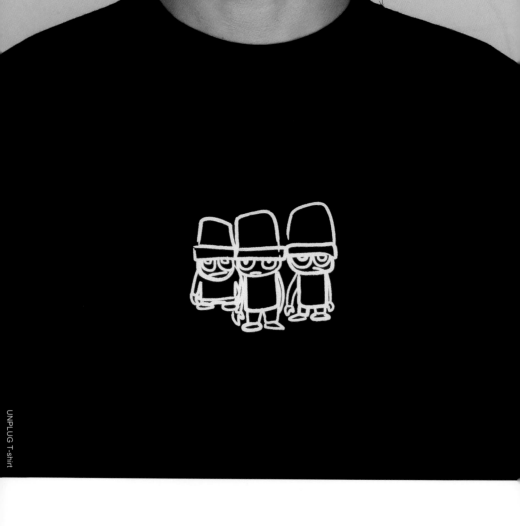

**356**
T-SHIRT

**357**
T-SHIRT

**358**
T-SHIRT

**359**
T-SHIRT

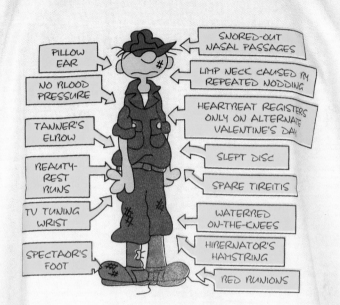

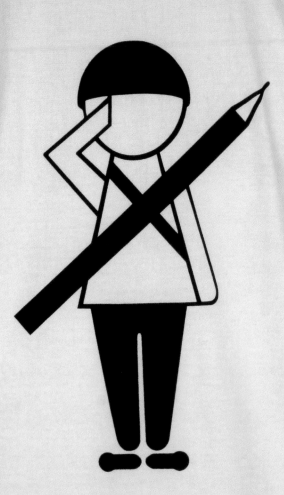

Humor is another element; often, humor is creative and implicit and a strong cultural indicator. A T-shirt with a pig on it and the words "Every part of pig is delicious food" is a form of French humor; a T-shirt with a zebra and the words "Hybrid between white and black" is from Britain. During the outbreak of SARS, a T-shirt saying "I am sterilized" was popular online; when the war in Iraq broke out, one U.S. website designed a T-shirt that read "America Bless God."

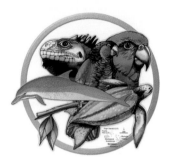

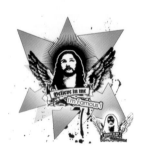

UNPLUG

UNPLUG

**365**
T-SHIRT

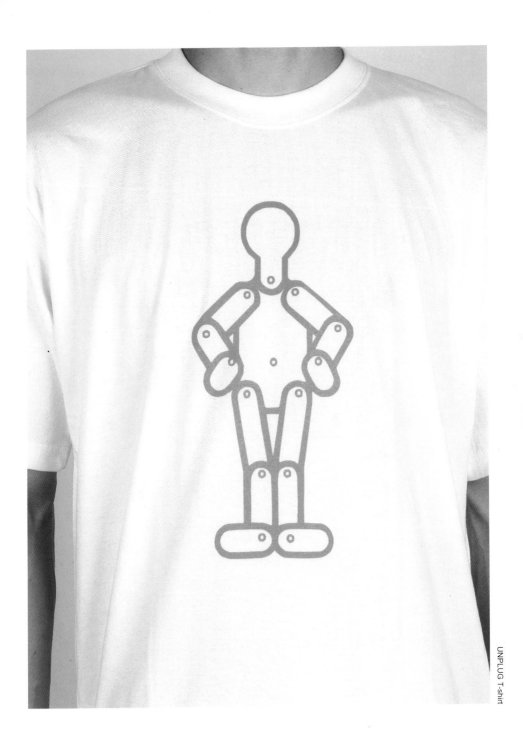

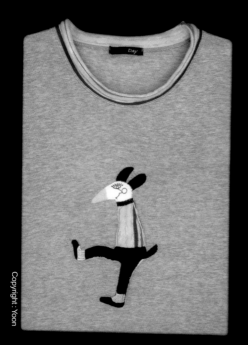

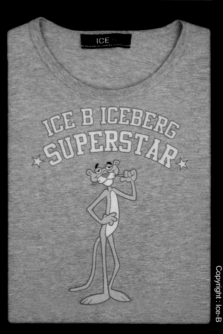

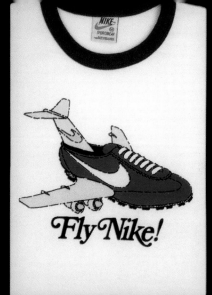

Fly Nike!

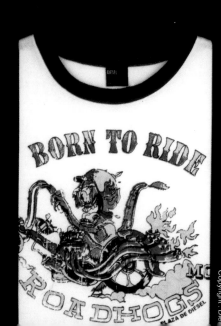

BORN TO RIDE

ROADHOGS

A T-shirt with no prints or graphics is a designer's favorite, for it is a blank canvas. Pure dark-colored T-shirts are the favorites of Giorgio Armani. A white T-shirt is crisp and clean. A black T-shirt is sexy, while a tight Lycra-blend T-shirt is a wardrobe must-have. In such colorful times, a pure-colored T-shirt always brings a sense of freshness and cleanness.

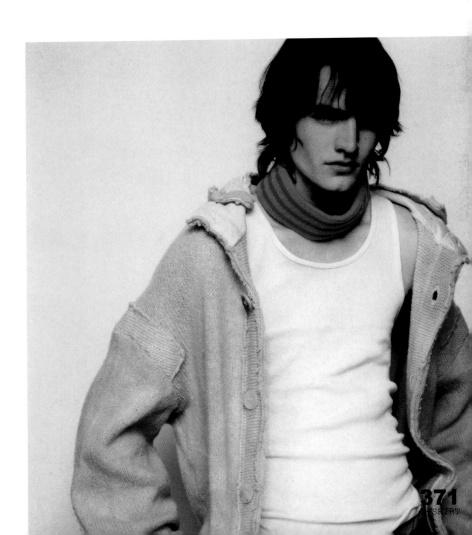

# Technique 8

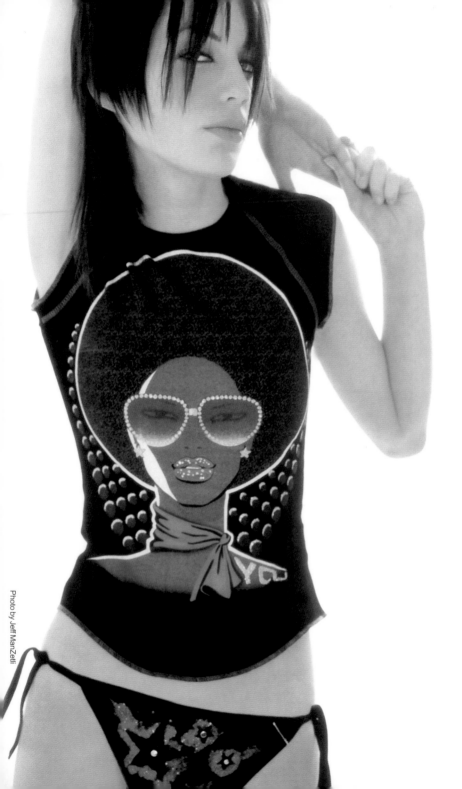

The history of texture can be dated back to ancient Rome. Romans used to wear two shirts, both of which were called *tunica*—one inner, one outer. That might be the first time there was a differentiation between underwear and outerwear. Shirts were developed from inner *tunica* as the underwear. In Roman times, tunica was made of linen, which could be called the first T-shirt material.

Cotton is mostly used in modern T-shirt production. With roots in India and Peru, cotton has a history of more than 4,000 years and was introduced to Europe during the seventeenth century. Before that, the Europeans knew nothing about cotton. The British Industrial Revolution made the mass production of textile possible, and cotton has been largely used ever since. Given cotton's cooling properties, it is little wonder that it has become the first choice in T-shirt production.

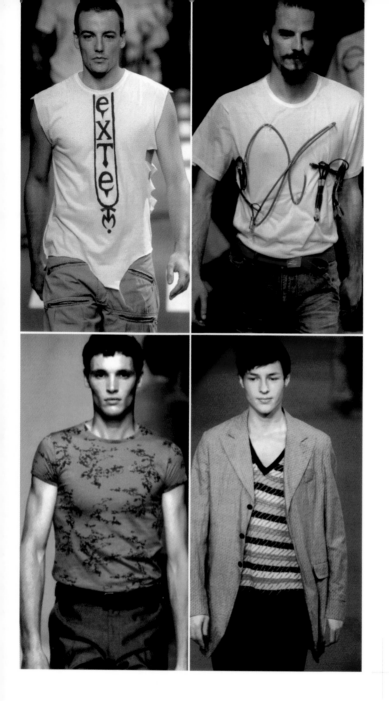

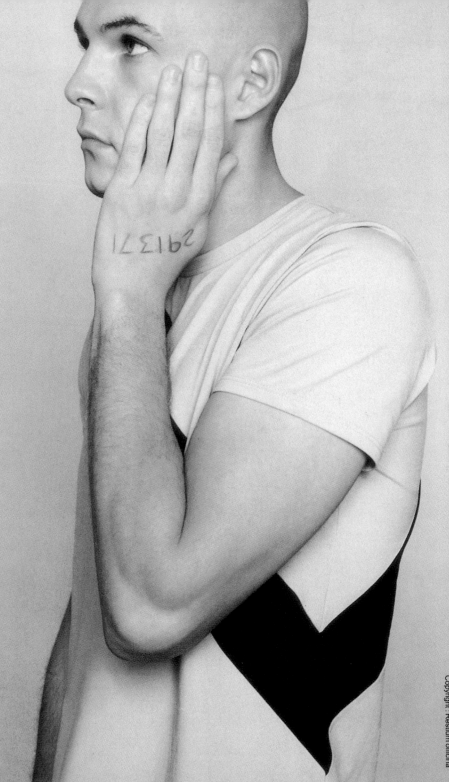

One hundred percent cotton has become the industry standard and a new T-shirt design company in the U.K. even named their brand "200%." In the 1960s, synthetic chemical materials broke cotton's monopoly. New materials were first used in athletic wear; these soft and easy-to-wash materials were introduced for better performance and ventilation. Lycra first appeared in underwear in the 1960s as well, and in 1976, Homix used 10% Lycra in its material. Meryl, Modal, and Coolmax have all successfully included Lycra in their materials. Generally, 5% Lycra is added to collars in order for them to keep their shape after washing, and some percentage of Lycra is added to fitted T-shirts, for figure-flattering shaping.

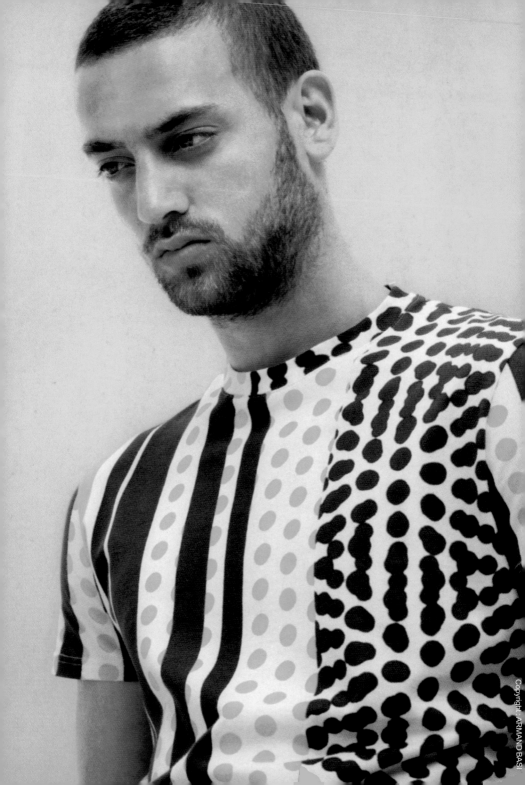

**380**
T-SHIRT

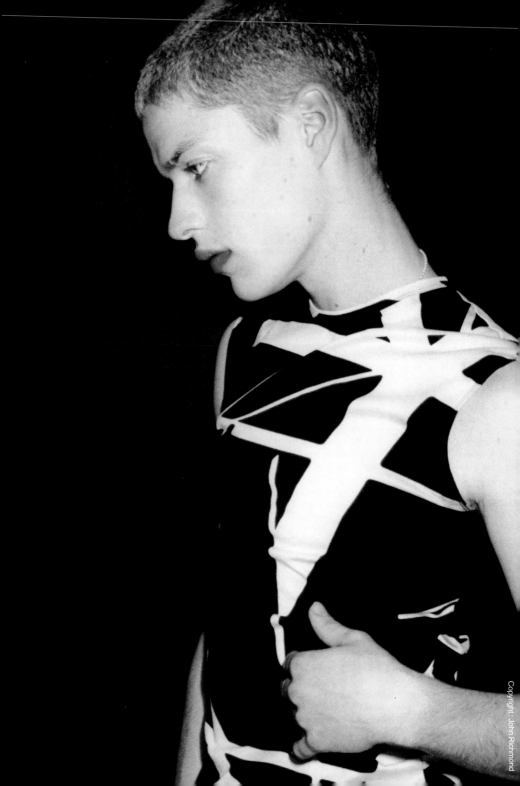

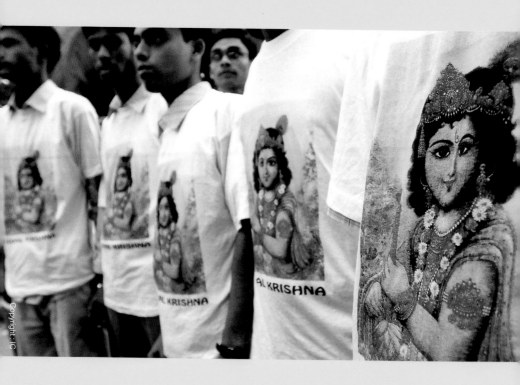

A big leap in T-shirt printing, thermal printing frees T-shirt printing from complicated silkscreen printing. With this technique, it only takes a few minutes to produce a T-shirt.

First, print the graphic with ink or on a laser jet printer on a thermal paper. Then, under high temperature and pressure, the graphic on paper is transferred onto the material. Another technique is to use thermal ink to print on normal paper, and then copy it onto the T-shirt material under high temperature and pressure. Nevertheless, this cannot be used on 100% cotton materials.

These instant printing processes are less complicated than the traditional silkscreen printing. It can offer a resolution of 300 dpi and create a half-tone effect. Because of the thermal paper, it is relatively expensive compared to silkscreen printing. However, it is better suited to meeting the individual needs of the market.

**384**
T-SHIRT

**385**

**386**
T-SHIRT

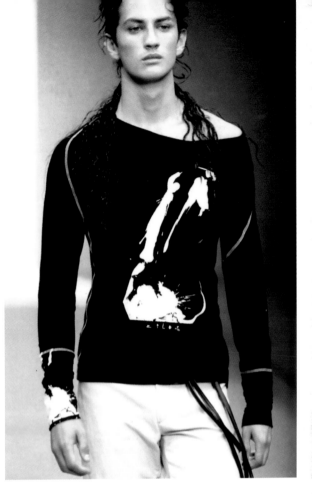

Silkscreen printing is the most used T-shirt printing technique. Its procedures include design, color separation, engraving, printing, and drying. Common design software can be used to create the design work. Unlike in traditional CMYK printing, each color needs a film in silk-screen printing before the colors are set together for printing. The resolution will be at 200 dpi. Brush the screen with light-sensitive glue and cover with film before exposing it to UV rays to make the engraving. Match the position and etch the graphics on the T-shirt.

Common printing materials include glue paste, water paste, and ink. Glue paste is the most common material because it has a tight coverage and is easy to dry, but it is hard to express details. Water paste feels soft and produces a higher resolution, but is less penetrating. Thermal ink is a new material that produces bright and detailed colors, works longer, is able to print CMYK plus silk-screen effects, but it takes 320°F (160°C) to dry and costs more. Other special materials include foam, floss, and protruding printing materials.

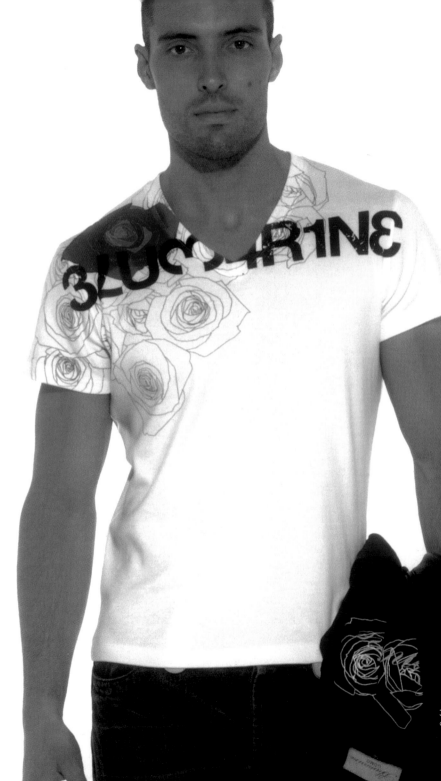

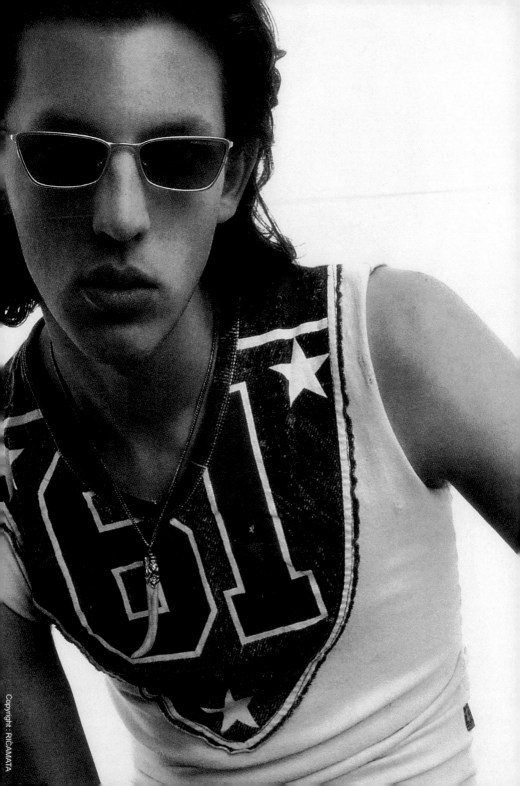

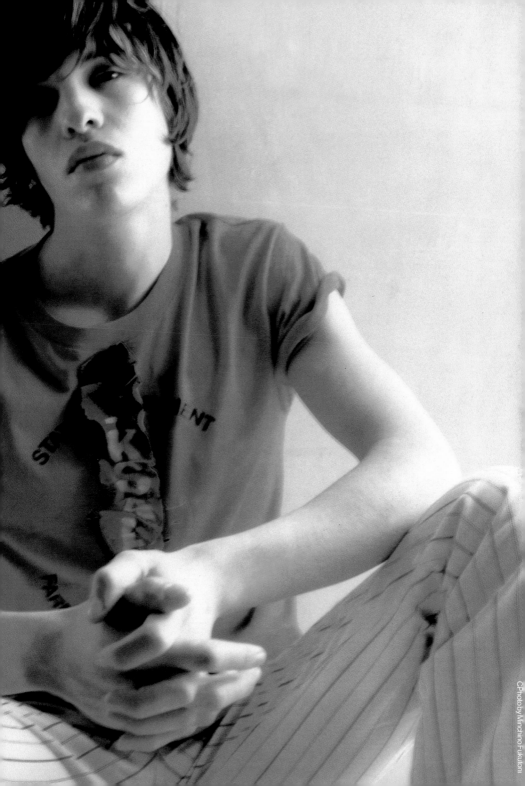

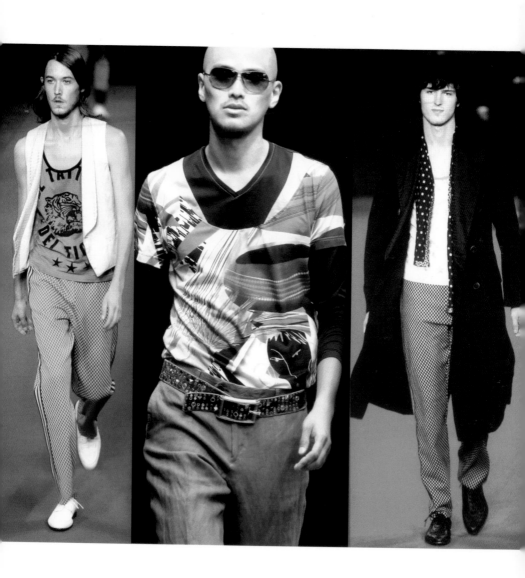

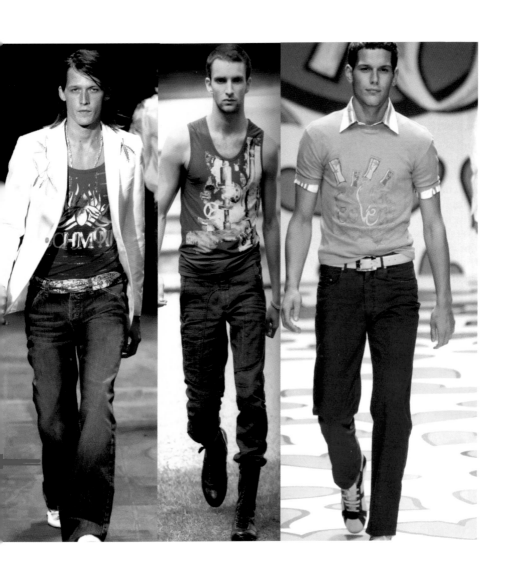

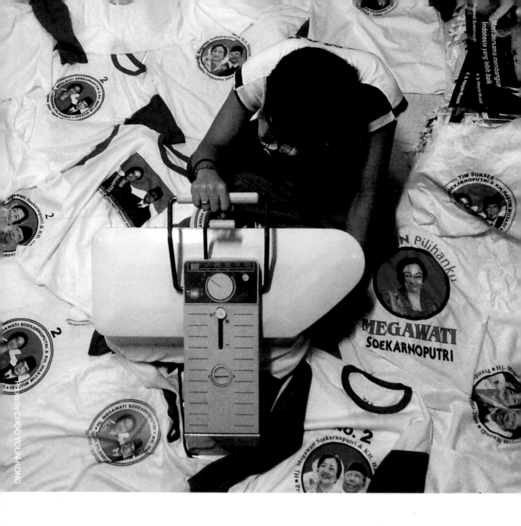

PHOTO BY CHOO YOUN-KONG

Screen printing is suitable for the mass production of T-shirt designs. Versatile, modern T-shirt printing machines can produce up to 1,200 pieces per hour. To cover the costs of color separation, a screen printer will often require a minimum T-shirt order. For small quantities or customized creations, thermal printing is the better choice. Printer companies have improved their thermal papers and now graphics from ink-jet printers can be transferred directly onto fabric with an electric iron. Thus, the truly personalized T-shirt can now be achieved.

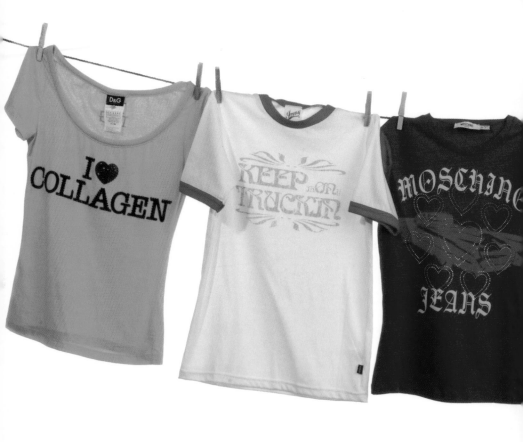

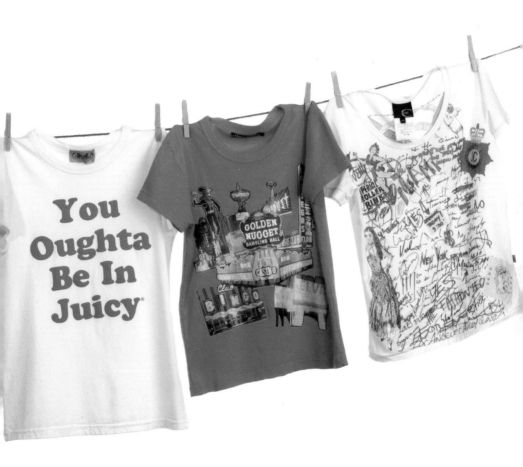

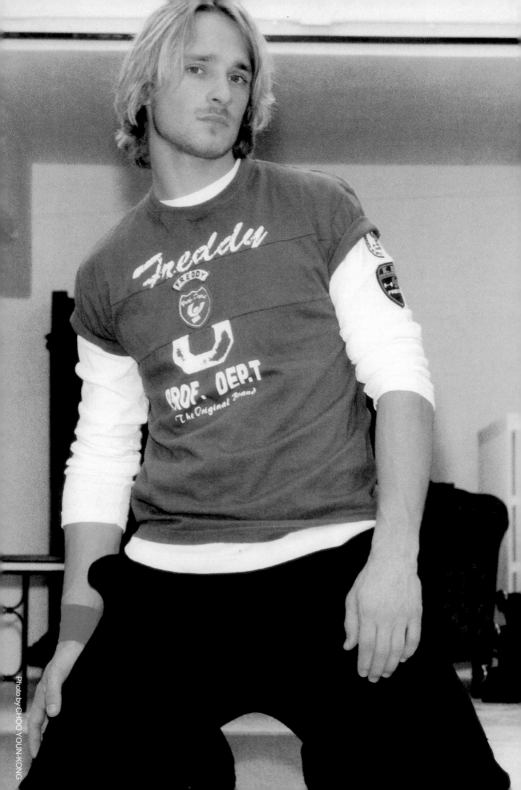

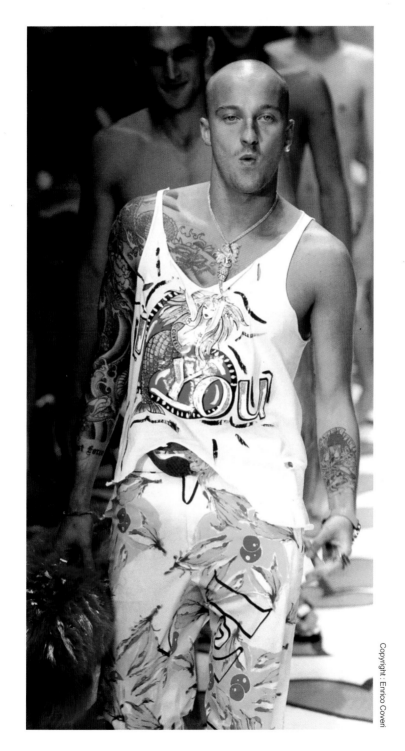

**399**
T-SHIRT

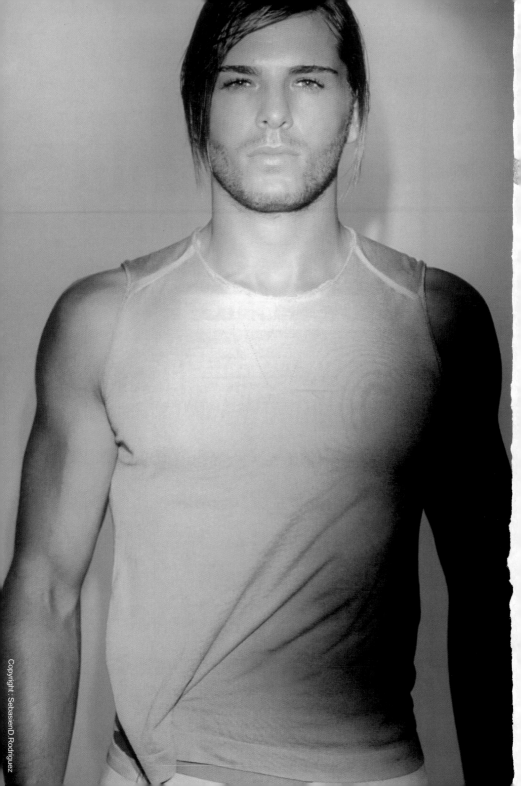